For Joyce, Joseph, and Christopher

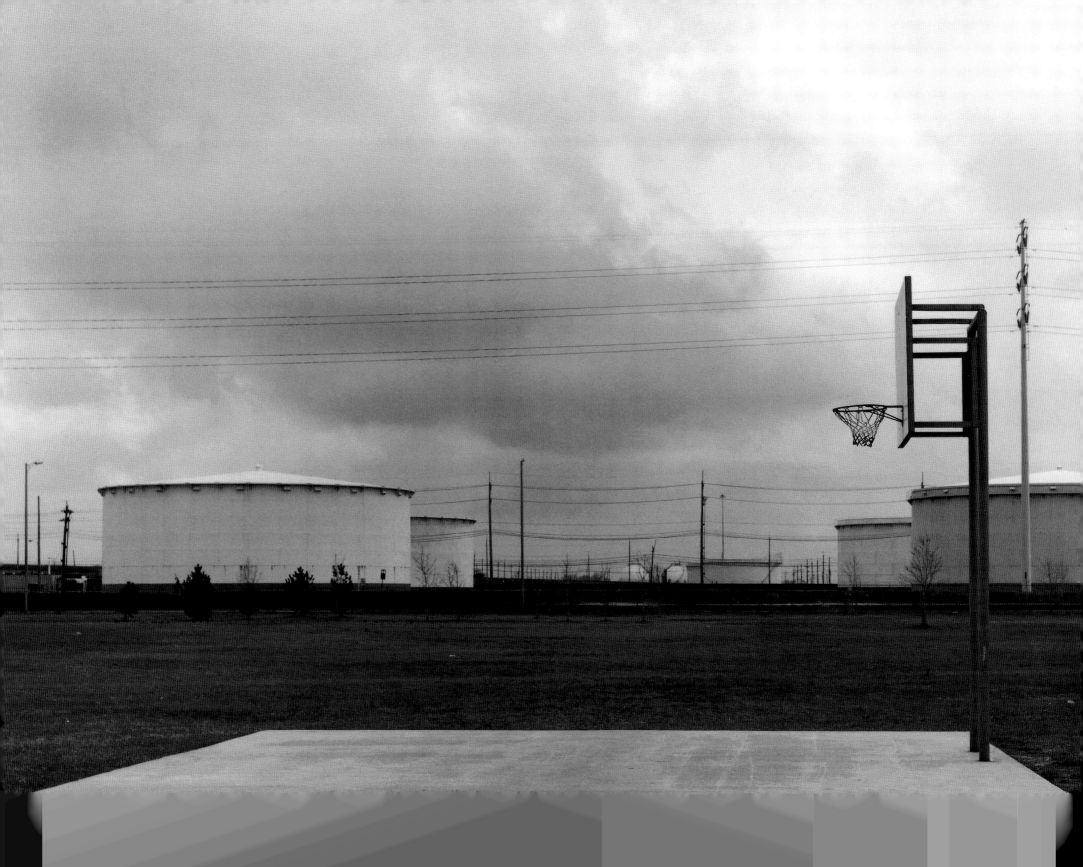

Designed and typeset by The Grillo Group, Inc., Chicago.

Color separations by Professional Graphics, Inc., Rockford, Illinois.

Manufactured in China by Four Colour Imports.

Library of Congress Cataloging-in-Publication Data

Photographs by Gary Cialdella

Edited by Gregg Hertzlieb

The Calumet Region: An American Place

 p. cm.

ISBN 978-0252-03456-5 (cloth)

1. Calumet Region (Ill. and Ind.)—Pictorial works. 2. Calumet
Region (Ill. and Ind.)—Social life and customs—Pictorial works.
3. Landscape—Calumet Region (Ill. and Ind.)—Pictorial works.
4. Calumet Region (Ill. and Ind.)—History, Local—Pictorial works.
5. Historic buildings—Calumet Region (Ill. and Ind.)—Pictorial
works. 6. Landscape photography—Calumet Region (Ill. and Ind.)
I. Hertzlieb, Gregg. II. Title.

F547.C7C53 2009
977.2—dc22
2008037942

VALPARAISO®
UNIVERSITY

Edited by GREGG HERTZLIEB

Essays by GREGG HERTZLIEB, GARY CIALDELLA, and JOHN RUFF

THE CALUMET REGION

An American Place Photographs by Gary Cialdella

University of Illinois Press, Urbana and Chicago, and Brauer Museum of Art, Valparaiso University

Introduction: Gary Cialdella's Shared History
Gregg Hertzlieb

This book of photographs from Gary Cialdella's *Calumet Series* represents for me the culmination of an adventure in learning and seeing that began in 2001. It started with a letter from the noted Oregon artist Robert Kostka (1928–2005).

Kostka and Richard H. W. Brauer, the founding director of the Brauer Museum of Art, had been close friends for many years, since their student days together at Chicago's acclaimed Institute of Design. Kostka became an important donor to the museum, vastly enhancing the Brauer's collection through generous donations, particularly in the area of photography. Richard Brauer would occasionally show me letters from Kostka that contained interesting information about certain objects he had donated, developments in contemporary art, or exhibitions worth seeing. I commented to Dick that I found Kostka's letters to be delightful, full of insight and ideas. "Do you think," I asked, "that Bob Kostka would be interested in corresponding with me?" Dick had described me to Bob in earlier letters as the new director/curator of the museum, someone who shared their fondness for modern art, and he believed that Bob would enjoy hearing from me. Thus he recommended that I send him a letter. For several months I wrote to Kostka, and the letters I received in return were full of information, and full of sensitivity. I have saved them all, and I am so glad that I pursued this enjoyable correspondence with an artist I admired but never actually met face to face.

In a March 2001 letter, Kostka included an announcement card for an exhibition. A photographer named Gary Cialdella would be showing his *Calumet Series* of black and white photographs from April to mid-May at the Gallery at Stevenson Union, Southern Oregon University, in Ashland, Oregon. I looked carefully for several minutes at the image on the card—a brick house that seemed to be sitting in the midst of a tank farm and oil refinery, surrounded by ground and sky in elegant gray tones. The situation struck me as strange: a friend and artist from Oregon was letting me know about an exhibition in Oregon of a photographer from Michigan who had created a series of images of the Calumet Region in Northwest Indiana. But any strangeness I felt quickly gave way to a feeling of excitement. First of all, the image on the card was simply beautiful, showing the juxtaposition of the residential and industrial that has always fascinated me as a feature of life in Northwest Indiana. Second of all, as director/curator of a Northwest Indiana museum, I thought that perhaps the Brauer could have an exhibition of this *Calumet Series*, which was bound to be of considerable interest to campus and community members for so artfully capturing the particular and distinct face of the Region.

Soon after I received the postcard, I located Cialdella's phone number and called him. I described how I had learned about his work and mentioned that I had viewed a number of visuals of his pieces online. I asked him to send me additional examples of his *Calumet Series* images, and we began discussing the possibility of his having an exhibition at the Brauer. Cialdella seemed entertained by my story of having learned about his Calumet work by way of Oregon, and he was generally interested in a Brauer Museum show. He also related to me that he had a personal connection to the Calumet Region beyond his

photographic project: he had grown up in Blue Island, Illinois. The additional visuals he sent me confirmed in my mind that fate had brought a major photographer to my doorstep, someone who had expertly chronicled an area of the United States that in my opinion needed to be studied, understood, and appreciated for its complexity and national importance. In the fall of 2003, we had a Cialdella exhibition of twenty-six Calumet images at the museum. It was every bit as popular with our viewers as I had hoped and thought it would be. We even purchased a piece, "Backyard, Reese Street, Robertsdale Neighborhood, Hammond, Indiana, 1999," for our permanent collection, which we display frequently as representing both an intriguing view of the Region and a well-executed gelatin silver print.

Although my strong appreciation for Cialdella's work is based largely on the high quality of the photographs themselves, it arises partly from my familiarity with and fondness for the Calumet Region. I am a native of Northwest Indiana, having spent my first ten years in Highland before moving with my family to Merrillville, where we lived for four years, and then moving again to Chesterton, where I attended high school. I went to college in Decatur, Illinois; London, England; and Chicago, Illinois, living on the north side of Chicago for approximately six years before I returned to Chesterton to take a job teaching art and English at the high school from which I had graduated. Around the time I started teaching, I bought a house in Chesterton, and I have lived in that same house since 1991. I left high school teaching in early 2000 and have been at the Brauer Museum of Art since shortly thereafter.

95TH STREET BRIDGE, view south toward Railroad Bridge, Calumet River, Chicago, 2002

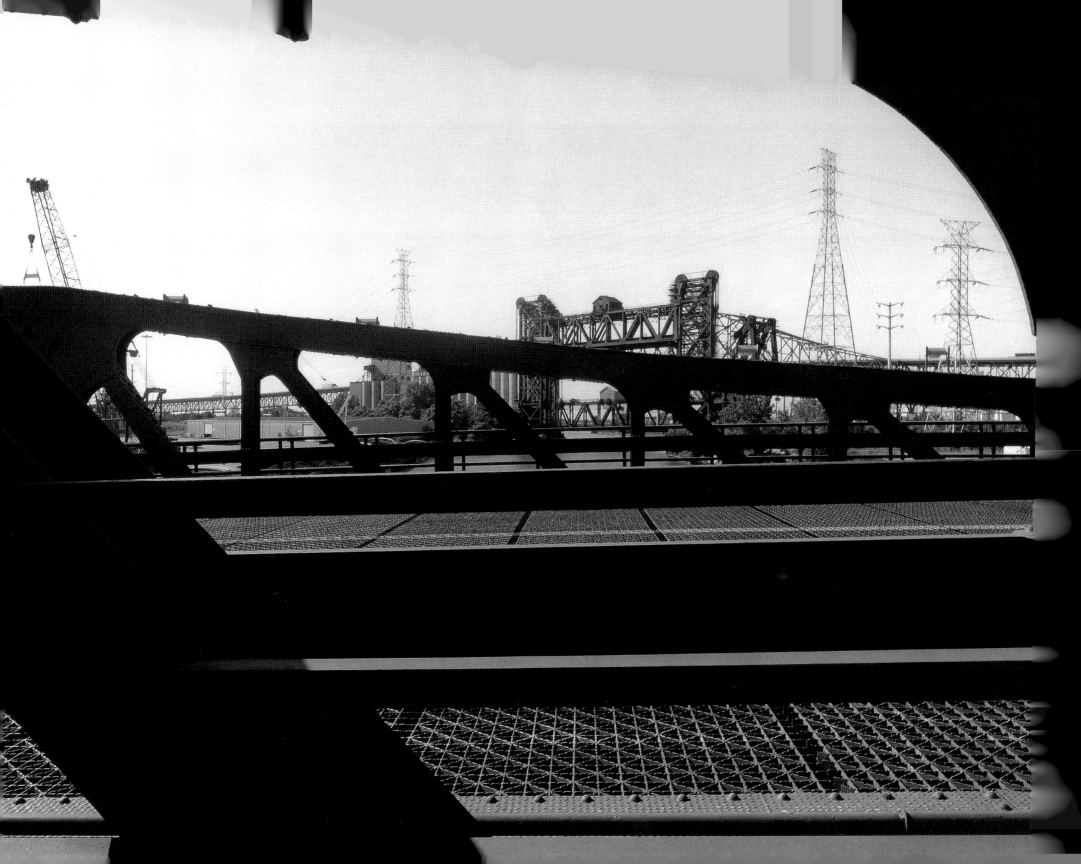

I offer these autobiographical details to point out that I have spent most of my life in Lake and Porter counties in Northwest Indiana. Nearly every other week, I drive through Hammond or Gary for one reason or another, visit my mother in Munster, and run errands that take me through East Chicago or Whiting. I remember as a child playing with my brother on an actual full-sized tank in the park north of the courthouse in downtown East Chicago, across Indianapolis Boulevard from Security Federal, where my mother worked on a computer system that filled an entire back room of the bank. I remember listening to the O'Jays and Curtis Mayfield on the car radio as we drove to visit my great-grandmother in Hammond, just northwest of 165th and Calumet Avenue. I remember riding along Indianapolis Boulevard in a typically enormous car in the late 1970s, seeing refineries on both sides of the street that seemed to go on forever, as if we had driven into a world of industry, full of lights, pipes, flames, smoke, and steam. I once saw a magnificent flame atop a pipe within the structure of a refinery and asked my father how tall he believed it to be. "About one hundred feet or so, I would guess," he said. I was fascinated by the thought of a flame reaching a hundred feet into the sky, and I think about that exchange from my youth every time I see a similar pipe and flame at the Whiting refineries or at one of the various landfills in this area.

When we lived in Highland, my grandfather occasionally stopped by the house after working all day at the steel mill. My brother and I would always ask him to flex his biceps, revealing muscles the size of coconuts, an indication of the hard physical work that he did. It seemed that the parents of my elementary school and middle school classmates all worked in the mills, and all of us youngsters believed (or at least thought from time to time) that we too would eventually be involved with the mills in some capacity, possibly watching on with fear and respect as cauldrons of molten steel passed overhead.

During the summers while I was in high school, I accompanied my stepfather on many steel erection jobs throughout Northwest Indiana and on the south side of Chicago. I suppose it was around this time in my life that I began to sense the beginnings of an artistic awareness of my surroundings. Tank farms captured my imagination, with the large white tanks standing almost like sentient presences within fields of blacktop and gravel. Joists and girders formed sculptural arrangements in the sky for me as I stood on the ground below, fetching tools and gear for the workers on my stepfather's crew who scurried on the structures above. The interiors of various factories and plants impressed me with their gigantic pieces of machinery, of a heaviness and mass that was impossible to truly comprehend.

I began to realize that I was discovering a personal aesthetic sensibility, and that sensibility seemed to be tied to or to arise from the heavy industry that had surrounded me throughout my life. Because I had no other frame of reference, I suppose in my early years I took the traits and elements of such settings for granted, assuming that most places were similar in appearance to the Region's weathered industrial face. Now, however, I found myself becoming aware that I had come from a place with a unique character, perhaps not a place possessed of the most conventionally glamorous characteristics, but a place with its own virtues, its own deep history—a place truly important to the development of this country.

This point brings me back to Gary Cialdella's dramatic photographs. Looking at his pictures helped me to understand even more that I came from someplace, that I had a home of which I could be proud. His pictures, inspired by the complex Calumet history he discovered (and knew firsthand as well, as someone with his own roots in the Region) and the striking juxtapositions of industry and domestic life unfolding in its shadow, are in a manner of speaking of my hometown, and collectively they offer me something of a portrait of myself. Through careful looking, I can discover traits in the photographs that give me insights into who I am and why I have the interests that I do.

I have made much the same point to countless visiting groups at the Brauer Museum, usually in the context of our Hudson River School works and paintings by the Dunes artist Frank V. Dudley: Artists teach us how to see. Without their calling our attention to what exists around us, we do not generally take the time to notice it, moving through our lives largely oblivious to the beauty (which may be challenging or unconventional beauty, but is beauty nonetheless) that can inspire us and make us aware of the surprising degree to which we have been shaped by places, including our homes.

In my own home lately, I have been looking closely at one of Cialdella's photographs—a fairly small picture for which I traded him a piece of my own art. The subject is a Whiting street. Cialdella works professionally as an architectural photographer and is obviously an expert at showing buildings to their best advantage, but something different happens with the buildings in these images: the picture is not "about" offering the viewer the most flattering view of its designed and constructed subjects. Instead, it has an intriguing narrative aspect that, to my mind, exemplifies the difference in goals between the realms of fine art and illustration. In the context of their Region surroundings, these houses assume an anthropomorphic aspect. They seem to lean in, begging for attention. The aluminum siding, shutters, roof details, and window treatments become traits that constitute faces (perhaps not literally configured, although that may be true in certain cases), convey physical states, and ultimately project personality. Cialdella's houses participate in his chosen scenes to say, "I am here, and in this place I have a distinctive identity. My design and the materials of my making are essentially tied to the place where I stand—and while standing here, I will show you who I am." The seeming look of defiance that I notice in his houses is the face of endurance: endurance of ethnic identity, endurance

"Artists teach us how to see. Without their calling our attention to what exists around us, we do not generally take the time to notice it..."

Gregg Hertzlieb

of hope despite changing economic circumstances, endurance of belief in values such as the merits of hard work and a simple life. I am consistently amazed by Cialdella's ability to make me forget that I am looking at images of houses and architectural subjects. I feel presences in his photographs that communicate to me, that seek my approval, that beg me to be aware of them so that I will not forget about them, that remind me that they have always been a part of my and my family's lives, and that urge me to see them until the seeing moves past my eyes into my heart.

Such effects of course belong to the area of personal interpretation. I cannot necessarily or in every case point to objective characteristics in the pictures that give me the sense that buildings have personalities— the art, after all, lies in the work's ability to inspire me as the viewer to create, to feel, and to empathize with the subjects. However, the sharing of personal reactions seems closed off and indulgent without at least an attempt to point to specific details in the pictures that lead to certain impressions. Cialdella's occasional use of symmetrical compositions, his careful composing through the camera viewfinder to eliminate extraneous information that takes the eye away from the primary subject, the way he gives subjects prominence of size within the frame, all work together to lend the architectural subjects in his pictures an iconic status that can lead to interpretations of the buildings as reflecting characteristics of defiance, pride, an assertive spirit in the face of adversity.

A formal characteristic of his *Calumet Series* work that I find especially important is his skillful manipulation of gray tones. Black and white photography is frequently associated with earlier eras, before the development of color photography, and might even have an air of severity about it. We take comfort in color and find delight in it, allowing it to lift our moods and spirits. Cialdella's use of black and white urges us to forget for a while the seductiveness of color to focus on what we see in the Calumet landscape. Networks of high-tension wires reach across the sky, while networks of cracks branch across the pavement. Bridge details surge forward, while signposts lean, and fences and windows play off each other's geometry. Clouds move across the sky to block the sun temporarily, allowing us to look around and take stock of the appearance of this place. Mills and factories stand resolutely looking on, realizing under the overcast gray that the grandness of their scale does not guarantee their survival even though they retain a dignified, even classic, appearance.

The artist's grays give such richness and depth to the photographs that we do not think of the pictures merely as pieces of paper with tones of various weights spread across the surface. We enter into these images and inhabit their places because the rich tones engage us and capture our attention. I think about how much easier it is to focus on the matters at hand on a cloudy day or when the sky is overcast, when I am not being charmed or distracted by the sunlight and sparkle of brighter days. Cialdella seems to wish to direct viewers toward a truth, not so much to draw them away from conventional beauty as to reveal the substantial beauty and poignancy that lies in a frank assessment of age and gradual metamorphosis.

I do not want to convey the idea that Gary Cialdella is simply a recorder of sad truths. History by its nature is always accompanied by some degree of melancholy, because the field makes us aware of time passing—and Cialdella is definitely a historian. But he is also an artist, always in the field to keep his eye sharp and his fertile imagination engaged. His images are often celebratory and exemplify what many feel is most interesting about photography: that it shows us a perfect moment that we otherwise would never have thought to see or notice. He is an explorer, going out with his camera to find places that, in their specificity, paradoxically speak to the condition of being an American and being a human being. As we go about our lives, wondering how we will help our communities adapt to changing circumstances, Cialdella records those wondering moments, showing us where we have come from and where we may be going. The pride of place we gain from looking at his images gives us the strength to move forward, to realize that what we as a community of people accomplished before can be accomplished again, as we are surrounded and reassured by the products of a noble past.

I am grateful to the artist for his thorough and expert study of an area that matters, but that maybe did not know it mattered because it was too immersed in rolling up its sleeves and peering confidently but slightly uncertainly into the future. I managed, through fortuitous circumstances, to find Gary Cialdella, and he, in turn, helped me to find myself.

The Calumet Region: An American Place

Gary Cialdella

As I write this essay, the *Chicago Tribune* is reporting that Union Tank Car in East Chicago, Indiana, has abruptly closed, moving its operations to non-union shops in Louisiana and Texas—an all too common story in the Calumet Region. The *Tribune* article noted that Northwest Indiana has lost more than two-thirds of the 89,000 jobs that it had in 1979. Today, the mostly Hispanic and African American population of East Chicago earns a median household income of $26,500. I grew up in a different time, when the Region was considered a manufacturing center, and anything you could imagine was made in, or was in some way connected to, the Calumet.

My family's house was on Artesian Avenue and 120th Street in Blue Island, Illinois. This neighborhood of mostly postwar homes was on Blue Island's north side, a block from the city of Chicago. When my parents had our three-bedroom brick home built, we moved from the Italian east side of town. Blue Island's Italian community was close-knit, and the move, although only a mile or so away, was a break from tradition. For my parents, who experienced the Great Depression, the move grew out of the desire to raise my sister and me in the mainstream of American life, to take our place in the growing middle class.

The neighborhood we left remained an important part of my childhood. My grandparents on both sides lived there, and we visited them on Sunday afternoons. The drive, although short, was exciting to a child. I eagerly anticipated crossing the Western Avenue wooden plank bridge over the Calumet Sag Channel. Riding in the back seat with my sister in our used 1953 Ford, with the sound of the car wheels over the loose planks and the murky water visible between the openings, was an adventure to a six-year-old boy.

The Cal Sag Channel runs just south of Blue Island's business district on Western Avenue. The house where my mother was raised is on Grove Street, two blocks east of Western Avenue. At the bottom of Grove Street hill, just before you reach what used to be my grandparents' home, are the Rock Island and the Illinois Central (today Metra) rail lines. My grandfather, in his later years, would sit in the car he no longer drove, keeping tabs with his railroad watch on the trains that passed by his house. In his working days, he had walked to his job at the Indiana Harbor Belt Railroad Blue Island Yard. Before we moved to Artesian Street, we lived on Canal Street, on the opposite side of the Cal Sag from my grandparents. To visit, we crossed the canal on the pedestrian Penny Bridge, so named for the fare people once paid to walk it.

A few blocks northeast of Grove Street is Division Street, the home of my father's family. Just down the block from their house is St. Donatus Church, where my dad was an altar boy and where our family attended Mass. Like my maternal grandfather, Grandpa Cialdella worked for the railroad. Blue Island is a tangle of railroads. Looking back, it seems that we were always stopped in the car waiting for a train to pass. A couple of miles from the rail lines on Artesian Street is the neighborhood of modest houses, with small yards and garages off alleys, where I spent my childhood. Mostly of brick, somewhat varied in style, these well-crafted homes can be found throughout the Region. Years later, I would trace the origins of my photographs of vernacular architecture to these houses in Blue Island.

It was a sunny day in the summer of 1955 when I became more fully aware of the wider region I lived in. While I was playing outdoors with some friends, we noticed a large mushroom-shaped cloud in the blue sky directly to the east. Immediately my thoughts were of atom bombs, but the reality was an explosion and fire at the Standard Oil Refinery at 129th Street and Indianapolis Boulevard in Whiting, Indiana. The size of that cloud and its apparent closeness to my neighborhood simultaneously shrank and expanded my world. The day after the explosion, I saw photographs of the disaster in the newspaper. They showed twisted and melted steel and the rubble where homes had stood only hours before. Years later I photographed the homes in Whiting that bordered the renamed Amoco Refinery.

Photographing the Calumet Region was an idea that evolved over time. Since graduating from college, my wife and I have made our home in Kalamazoo, Michigan, where I was teaching photography back then. At the time I was photographing rural landscapes of Michigan and the Midwest. In 1979 a friend and I, for a change of pace, took a day trip to East Chicago, Indiana, to photograph industrial subjects. The waltz tempo landscape of Michigan and Indiana turns operatic when you enter the Region. The steel mills of Gary and East Chicago and the oil refinery at Whiting grab your attention as you drive. One set of forms comes into your field of vision, only to be quickly replaced by others. Smoke from the mills, iron bridges, oil tanks, moving trains, and the roadway stream past like a sequence from Vertov's *Man with a Movie Camera*. I find the panoramic view from the highway dreamlike, a bit intoxicating. That day I photographed the construction of Cline Avenue, the raised highway being built adjacent to Inland Steel, and I made a few photographs of the bridges at Calumet Harbor. It would be seven years before I returned to begin this series.

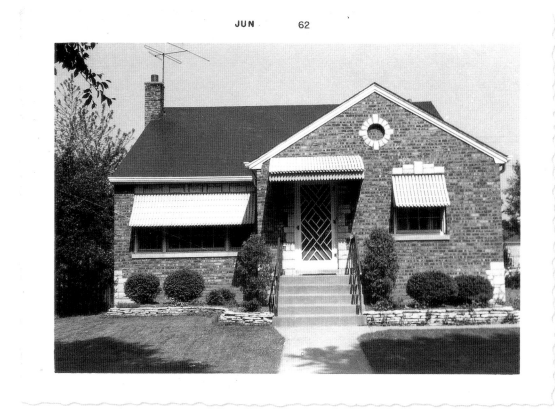

CIALDELLA FAMILY HOME, Artesian Street, Blue Island, Illinois, 1962

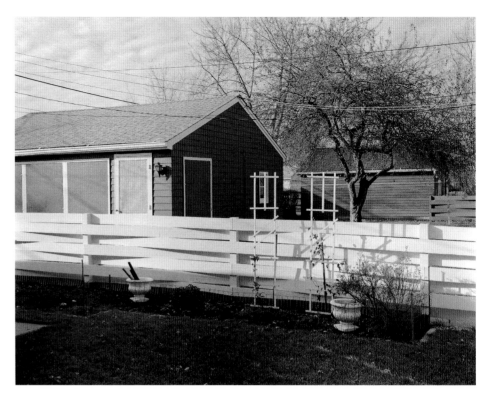

MY PARENTS' BACKYARD, Orchard Street, Blue Island, Illinois, 1985

I have heard the Calumet Region described as a "bewilderingly complex" place. That is an apt description: the Region is intertwined with numerous communities, railroad lines, waterways, natural environments, interstate highways, and increasingly brownfields. It encompasses the far south side of Chicago, adjacent south suburbs in Illinois, and the area eastward across the state line into Lake and Porter counties in Northwest Indiana. Defined by three geological moraines from the last ice age, these lowlands are now the site of aging industrial communities juxtaposed with delicate sand dunes and beaches. Little known outside the area, a large portion of the waterfront has been designated a National Lakeshore, an important natural area that was saved from development years before the environmental movement we know today existed. Small lakeshore communities such as Beverly Shores and Ogden Dunes are serene suburban places. Various photographers and painters have found their subjects in the sand dunes and marshland of this part of Indiana. My interest is elsewhere, in the industrial places, where the brash and confident American past meets the indecisive present.

Lake Michigan is the setting for the Region's industry—the lake's expanse a kind of balm to industrial sprawl. The belt of industry and neighborhoods hugging the shore defines this place and holds the most interest for me. Beginning in the Chicago neighborhood of South Chicago, at 87th Street and Lake Michigan, the home of U.S. Steel's South Works from 1880 to 1992, industrial development follows the contour of the lake's south shore eastward to the surviving U.S. Steel Works at Gary, Indiana. In between these two points, and three or four miles inland, is where most of the photographs in this book were made. The interplay of industry and domesticity that I found there fascinates me.

Memory and place are inherently linked. When I began working on this series in 1986, I started in Whiting, Indiana. At the time, I was producing a series of photographs of vernacular architecture. The homes bordering the Amoco (now BP) Refinery seemed like a logical extension of that work. The Standard Oil explosion of 1955 was certainly in my mind the first days I photographed on the streets next to the refinery. More significant was the uncanny sense of familiarity I felt. I knew those homes—not specifically the ones I was facing, but their type—and that experience placed me simultaneously back in my childhood and in the present. In *The Poetics of Space*, Gaston Bachelard writes that a "house is imagined as a concentrated being. It appeals to our consciousness of centrality." That summer I made numerous excursions to Whiting and the nearby neighborhoods of Hammond, Indiana, walking the streets with my 4 x 5 field camera photographing houses. The sense of place I experienced spoke to me, and without quite being aware of it, I began this project.

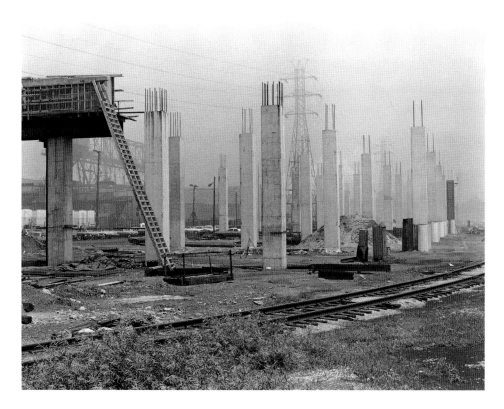

CLINE AVENUE OVERPASS CONSTRUCTION, East Chicago, Indiana, 1979

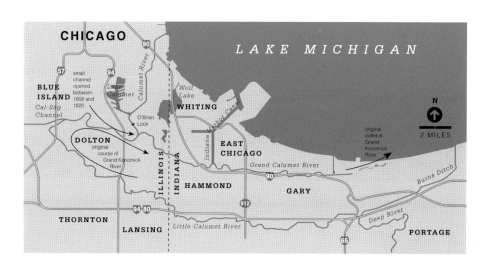

THE CALUMET REGION, Dennis McClendon, author. From James R. Grossman, Ann Durkin Keating, and Janice L. Reiff, eds., *The Encyclopedia of Chicago* (University of Chicago Press, 2004).

The first impression you have of these neighborhoods is one of sameness. It appears that there is little to distinguish one house from another. You could say the same about a crowd of people. It is the specific case that exemplifies. I photograph homes straight on, facing them as I might a person whose eyes are looking directly back at me. Seeing objects in this way emphasizes their particularity.

Whiting calls itself "the little city on the lake." At the north end of town is Lake Michigan. Located at the water's edge is Whiting Park, and immediately to its west is Wilhala County Park. Looking west across this narrow portion of the lake, you can see the skyline of the Chicago Loop. To the east, jutting out into the lake on a peninsula of landfill, are the mills of East Chicago, Indiana, and due north is the seemingly infinite sweep of the lake. When you are standing on the beach at Whiting Park, the appeal of this little city is more apparent.

The beauty of the lake is in stark contrast to other realities of life in the Region. In 1991, the stench of oil brought the residents living near Amoco's refinery to a forum to question company officials. Amoco had revealed earlier that a pool containing 16.8 million gallons of oil was located beneath the company's property, and that some of it was leaching under the nearby homes. The company sank test wells in Whiting streets to determine the extent of the spill. Amoco estimated that it would take twenty years to clean up the contaminated property. After reading about this incident, I drove to Whiting to see it for myself. The residential street bordering the west side of Whiting is Schrage Avenue. I found it barricaded, although rather subtly, with drooping yellow tape. I could see crews on the street apparently drilling test holes. A few years later, I photographed the empty lots where homes had once stood. At a corner where a pair of houses had been removed, a play area had been built.

In the late 1970s, I was introduced to the writings of cultural geographers. Particularly influential were D. W. Meinig, Yi-Fu Tuan, and J. B. Jackson, as well as the writer and critic John Berger, whose unique insights arise from a different tradition. Not only did their ideas help to shape my thinking about landscape and place, they confirmed what I had felt but not articulated: that ordinary places are important and worthy of our serious attention. When I started working in Calumet, it felt as if I had found the perfect place to photograph.

An industrial landscape possesses a place in ways that, for example, farmland or town squares do not. Calumet is a hodgepodge of conflicting values. It is an aggressive way to construct a place; it is about commerce and production above all else, and on the surface it is anything but inviting. Superimposed on this overcrowded landscape are the effects of popular culture. There is a harsh and affective poetry to the advertising, murals, and personal

"To this day I go out of my way to drive through the Region and take it in. Like so much of America, it is both sad and hopeful."

Gary Cialdella

ornamentation that decorate the streets and neighborhoods. A church mural and a billboard advertisement for a rock radio station may be poles apart in intention, but to me they read the same, as time capsules of our culture, saying as much about us as our national parks or our monuments do.

Photographing in the city of Gary, Indiana, revealed to me the most poignant emotional extremes. Gary's boom years peaked in the 1950s. The turbulence of the 1960s, white flight, and the riots following the assassination of Dr. Martin Luther King Jr. brought the city to its knees. When the financial resources fled Gary for the suburbs, the city was left with serious problems. These many years later, painfully slowly, the city is making its way back. A minor league baseball park and new housing projects are replacing parts of the largely abandoned center city, and a casino on Lake Michigan brings in the revenue to fund these new developments.

I photographed numerous buildings in Gary, mostly those that date from when the city was thriving but today reveal loss and decay. To look at them is to see history in the present moment, a perplexing duality of past stature and current demise. I see my work as both authenticating and elegizing this process. When I was photographing along Broadway, citizens of Gary often stopped to ask me why I was taking pictures. I told them about my project and about my interest in the old buildings. Invariably they would tell me a little bit of history, or direct me to other "important" buildings in the community. This attitude is not limited to Gary, and it speaks to the identification with place and the importance of historical memory imbued in the things we have built.

With every passing year, pieces of the Region's distinctiveness disappear. Familiarity with our surroundings is comforting. It is the source of our sense of place. However, we live in a society of constant change. Americans build and tear down and build again as no one else ever has. We call this progress. Even though today we are more conscious of preserving places than we once were, the creed of progress seems firmly intact. In *The Poetics of Space*, Bachelard writes that consciousness rejuvenates

everything, that things cherished are born of an "intimate light." I must have driven past the Inland Steel blast furnace adjacent to the Indiana Harbor Canal a dozen times or more before I photographed it in 2002. That day, for some reason, I felt the presence of the dormant furnace, its weight, more strongly than usual. One of the oldest furnaces in the Region, it was in operation from the first decade of the twentieth century until the late 1980s. A year or so after I made the photograph, it was torn down. The land where it stood is now a void.

I have organized this book in the same way I experienced the place, from the neighborhoods outward to the adjacent industry and to the expanse of the Great Lake. It is a place I know, and one that continues to surprise me. I have tried to put into pictures the complexity of my feelings for it. To this day, I go out of my way to drive through the Region and take it in. Like so much of America, it is both sad and hopeful. I see the Region as a unique place, but I see it also as a metaphor for the contemporary American landscape. Calumet is a real place, and it is home.

RAILROAD BRIDGE, Calumet River, Chicago, 1979

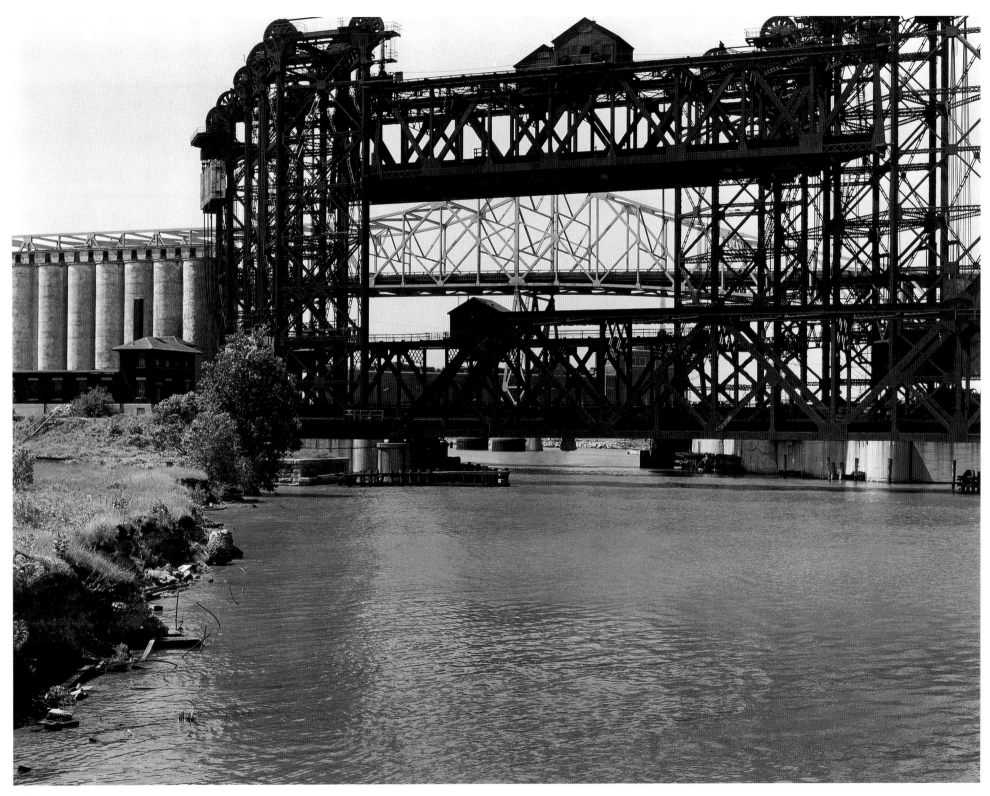

The Calumet Region Photographs: Requiem For a Heavyweight

John Ruff

I have lived in Northwest Indiana, in the Porter County town of Valparaiso, since I accepted a position teaching English at Valparaiso University in 1989. The county seat, Valparaiso was historically a town where management from the steel mills on the south shore of Lake Michigan chose to live and raise their families. Now the mills are mostly shut down, and Valparaiso University has become one of the larger employers in this area, if it is not in fact the largest. I live in a modest one-story home in an old neighborhood called Forest Park, aptly named for the abundance of red and white oaks, shagbark hickories, and maple, tulip, and black walnut trees that still thrive here, probably because the Valparaiso Moraine left the landscape too rumpled with ravines to make it good farmland. Everywhere else in Indiana that Hoosier farmers wanted to plow, they plowed.

The south shore of Lake Michigan lies twelve miles straight north out my study window. To the west down that shore are Burns Harbor, Gary, East Chicago, and Whiting—the rusting remains of Indiana steel country, once one of the most powerful manufacturing centers in the world. At intervals along the shore, between mills and power plants, hemmed in between Lake Michigan and a major transportation corridor into which four interstate highways funnel, lie segments of the National Lakeshore and Indiana Dunes State Park. These preserves protect a complex, ever-shifting, extremely diverse ecosystem, fragile even without the effects of massive industrialization in a burgeoning population center. Thanks to the efforts of Chicago-area nature lovers who fought to preserve it, what remains of this set of dunes and wetlands, the very place where the study of plant succession and modern ecology was born, is a remarkable treasure.

I have to confess, having come from Minnesota, having lived in Rome, Italy, then southern Oregon, and then Seattle, Washington, that I was not prepared to find Northwest Indiana such a starkly beautiful place.

The Brauer Museum of Art at Valparaiso University has an impressive collection of paintings by Chicago-area painter Frank V. Dudley (1868–1957), who more than any other artist taught the rest of us how to see and appreciate the stunning natural beauty of the Dunes. It is an open question how much of the lakeshore would have survived unspoiled without him. At Valparaiso University, I often teach an American studies course on American literature and landscape, in which we consider the literary and artistic development of the United States river system by river system, usually beginning with the Hudson River Valley, to which so many important cultural origins can be traced. My purpose is to explore how these texts, verbally and visually, lay bare our attitudes, beliefs, and ambivalences about the land, how we possess it, and how it possesses us. Lately I have been trying to do more with the local story, and Dudley helps. The preservation of the Dunes is important, with wide-reaching implications for our nation and for these times. Can our economy rebound? Can our human and natural resources be sustained? As I ponder these issues, I am excited about exploring the landscape that Gary Cialdella is teaching me to see in his Calumet Regions series of photographs. It is not like any other landscape I know, and Cialdella's eye for its stunning truths and beauties is acute.

I first became aware of Cialdella's work when the Brauer Museum hosted a small exhibit of his *Calumet Series* photos a couple of years ago. I had long been a fan of Charles Scheeler's great photographs and paintings of the Ford Plant at River Rouge, Michigan. No one before Scheeler had captured better the heroic

sublimity of that first great cathedral of American industrial power. Scheeler struck me as a later, quieter, visual version of Walt Whitman, celebrating the muscle, the know-how, and the energy of American industry. Cialdella is also drawn to such heroic images, and they are abundant in his series. My preference is for landscapes dominated by power pylons, oil refinery tanks, and bridges. Cialdella has a great eye, and makes great operatic visual poetry of this region's "body electric." If I had to pick a favorite, though, it would probably be his image titled "Grand Calumet River, East Chicago, Indiana, 2002" (page 104), which is quieter, more static and contemplative. What moves me in this image is the way the eye is led up past the rush-filled banks of the quiet river into a field of refinery tanks and power pylons. More than most of the images in the series that put the manmade and the natural worlds in dialogue, here we observe a rare sense of harmony and balance, perhaps the effect of Cialdella's having put the tanks midway up the picture plane at eye level, so that they are less imposing than usual, barely rising above the tall grasses in front of them. The image is largely water and sky, in almost equal proportions, the water clear and placid under a sky much less leaden than usual—a sunset, in fact, such as would attract the camera of a photographer much more interested in the conventionally beautiful than Cialdella seems to be. But beautiful it is, and thematically nuanced and rich, this quiet icon for the Region, for its river, and for its resources.

But as Gregg Hertzlieb points out, it is the uncanny proximity of the residential and the industrial in the working-class neighborhoods of the Calumet Region for which Cialdella has an unfailing eye, as well as the way the manmade industrial landscape interacts

with, and often dwarfs, what stands against it representing the natural and sometimes spiritual world. From that first show I saw of Cialdella's work, the image that most knocked me out was of a fenced backyard full of lawn ornaments—deer, ducks, bunnies, a birdbath, little people fishing, a couple in a swing, all gathered around a carefully constructed pool ("Backyard, Reese Street, Robertsdale Neighborhood, Hammond, Indiana,1999," page 42). The more I study the image, the more uncanny it becomes— like a nature preserve but with artificial animals and artificial people, a tableau vivant of unnatural natural harmony, but with no way in and no way out. It appears to me that this rectangular island of artifice extends well beyond where I imagine the lot line should be, and nowhere is there evidence of a gate. There is a patio with patio furniture, sans cushions. So who ever sits there, to view and be viewed in this setting? Ultimately it is the carefully tended chain link fence that dominates my attention, how it both protects and imprisons, how it both admits my gaze and blocks it, as vinyl lattice strips woven in a diagonal pattern through the back fence partially obstruct my view of the alley.

I love how Cialdella takes us into the backyards and down the alleys of the working-class neighborhoods of the Calumet Region, into carefully tended private outdoor spaces that both expose and conceal the owners, like the images of their house fronts, straight-on shots that in the same instant can be so revealing and yet so opaque. Cialdella doesn't pry with his camera, but he doesn't flinch, either. This is particularly true in his rendering of more public civic and commercial landscapes of the Region. Whereas Scheeler's art shows us American industrial might,

Cialdella documents its decline and ruin. He shows us the junk, the refuse, the rust. He takes us to the entrance of a junkyard; he shows us boarded-up storefronts, vacant lots, abandoned factories. When I think of Scheeler and Cialdella together, I think of Thomas Cole's famous series of paintings *The Course of Empire*. In that series of five paintings, as if anticipating time-lapse photography, Cole renders the same locale as he imagines it being transformed, socially, economically, politically, even geologically, through time. It is a tragic vision of human history that culminates in the kinds of picturesque ruins that Cole's generation of American painters had to go to Europe to paint. Cialdella, at a different point in the course of American Empire than Cole and Scheeler, has ample opportunity to render American ruins in Gary, East Chicago, and Whiting, and he captures them with great realism and pathos.

Gregg Hertzlieb claims that Gary Cialdella's photographs of the Calumet Region bring him home. That both is and is not the case for me. I grew up far from the Region, on the corner of Dowling Avenue and York Avenue in Robbinsdale, Minnesota, a northern suburb of Minneapolis. Our two-story home, bigger than many in Cialdella's book (but barely big enough for what eventually became the ten of us), faced a tree-lined greenway, Victory Memorial Drive, which physically insulated us from North Minneapolis while connecting us to a wonderful parkway system linking Minneapolis and its beautiful chain of lakes from north to south. Depending on the season, neighborhood kids played pickup games of baseball or football on the drive whenever enough of us could gather, which was often. There were lots of kids to play with—this was in the sixties and early seventies— and no adults were involved. This was long before children lost their right of assembly for unorganized spectatorless sport.

No refineries or mills or railroad trestles interrupted the view out my bedroom window across the drive. Only the bell tower of St. Austin's Catholic Church on the corner of Vincent and Dowling rose higher than the roofs and treetops. But I do connect to these Calumet Region photos, in a number of ways. First, there is a family connection, through my mother, whose father and brother and two nephews spent their entire careers working for Williams Steel and Hardware in North Minneapolis—my grandfather as the company's best salesman for forty years, my uncle and his eldest son as salesmen who each rose up through the corporate ranks to become president of the company.

Williams Steel has been an institution in North Minneapolis for almost 150 years. In the 1860s, Joshua Williams ran a hardware store on Hennepin Avenue in downtown Minneapolis that served local builders and blacksmiths. That store evolved into Williams Steel and Hardware, an iron, steel, and hardware wholesaler serving the Upper Midwest from its landmark warehouse off Lowry Avenue on the east bank of the Mississippi River. My cousin Thomas Young, the current president of Williams, has spent his whole term in office, since 1999, presiding over the downsizing of the company that his father and his grandfather helped to build—the company whose decline both saw coming but neither could do anything to prevent.

It was in sixth grade that I first began to learn about the role that steel played not just in my family but in my state's history. In geography class at St. Austin's Catholic School, we learned that the richest deposit of iron ore in the entire world came from our state. I once thought, hoped, believed, that the words "*Mesabi Range*" spread across the northern part of the

map of Minnesota in rippled italic letters referred to mountains, and in a sense they did—but mountains of iron ore, buried underground, which long before I was born were being torn out of the earth, loaded onto ore boats, and shipped across Lake Superior and Lake Michigan to ports in Illinois and Indiana, near mills whose satanic furnaces burned day and night to turn it into steel to gird the nation and win its wars. Victory Memorial Drive, with its stately elms and the memorial markers we used for bases or sidelines, was designed as a tribute to Minnesota's war dead, but it was also a memorial to the victory of American steel, of American manufacturing and agriculture in the making of the postwar world.

I was still a teenager when they developed the process for turning low-grade iron ore into taconite pellets, which I now know marked the beginning of the end of a long, proud tradition of iron mining in Minnesota. My father, an advertising executive in the late 1970s, managed his company's account with 3M Corporation (the Minnesota Mining and Manufacturing Company), one of Minnesota's strongest, oldest Fortune 500 companies, for my era much better known as the inventor and manufacturer of Scotch Tape and Post-it Notes than for mining. The sad fact is, my whole life, the northern part of Minnesota has been economically depressed, and the American steel industry has been headed into decline—not unrelated facts by any means.

So I connect emotionally with Gary Cialdella's eloquent elegy to the Calumet Region and all it once stood for, as a fellow Midwesterner with family ties to a proud tradition of American manufacturing and to the American steel industry. And the photographs do bring me home, by helping me remember where I came from and what privileges I enjoyed, by helping me see my surroundings as both like and unlike the setting where Gary Cialdella and Gregg Hertzlieb came of age. I think about the house on the corner that I grew up in, with the shapely Colorado blue spruce out front and the greenway across the street, when I look at Cialdella's amazing image of another two-story house on a corner, with three bare trees out front, slender, shapely, and spectral against a background dominated by huge oil tanks beyond a chain link fence ("House and Oil Storage Tanks, Hammond, Indiana, 1989," page 57). I am struck by the scale of things, the understated assertion of a natural world by the bare trees, versus the muscular, abstract dominance of the manmade industrial world. I see empty trees versus capacious tanks, and between them a two-story brick house, absolutely unornamented. Unlike most of the homes in the series, this one was shot in profile, most likely to capture the juxtaposition I have been talking about, thus situating this human dwelling smack in the middle of these contending worlds, the natural versus the industrial. The image is so starkly beautiful, so tonally evocative, the forms so full. Has anyone made more visual poetry of refinery tanks than Gary Cialdella?

There is another image of a house on a corner that speaks to me, this one taken from the back and also from the side ("Schrage Avenue and 126th Street, Whiting, Indiana, 1999," page 33). The cropping of the image on the left and at the top allows us to see only part of a two-story house, making central the unattached brick one-car garage beside it, which forms a backward L with the house. The wall of the garage facing us at a slight diagonal has two windows dressed with Venetian blinds; there are window boxes beneath them luxuriant with flowers, and a set of planters lush with tall greenery forms a border for the patio that extends the length of the garage to the back door of the house. Against that wall of the garage, framed by the windows, between two shorter standing planters and a single hanging planter, stands a birdbath, which serves as a pedestal for a statue of the Madonna, who stands in a bed of flowers, and whose head seems to be adorned with flowers. This is not the only backyard shrine that Cialdella captures in the series—Madonnas recur quietly throughout these increasingly Hispanic working-class neighborhoods—but the composition of this backyard, the meticulous care with which this shrine to domesticity has been created, against a backdrop just beyond the garage of refinery smokestacks and holding tanks, is nothing short of breathtaking. It is a perfectly composed photograph of a perfectly composed backyard, one particularly important corner of someone's yard, of someone's life, where one assertion of what is holy, human, and beautiful is starkly set against a different assertion of power, value, and meaning. The white Madonna, in her humble and tiny uprightness, invites comparison with the equally white but more massive oil tank. Between them, of course, with its broad white door, is the garage, brick citadel and ornamented refuge for the idle and protected automobile, around which so much of this cross-cultural dialogue revolves.

Speaking of garages, when I was old enough to throw a basketball ten feet into the air, my dad nailed a backboard to our two-car garage. Cialdella's image of a '57 Chevy up on a jack, inside the tiny fenced backyard of a house in Whiting, with a much-used basketball standard framing the scene like one of those Roman pines in a Claude Lorrain landscape ("'57 Chevy, Whiting, Indiana, 1999," page 30), well, it takes me back to my home court, where I'm in a tight man-to-man defense against myself as I play both teams, coaches, referees, scorer, and crazed announcer: "He shoots, he scores, and he was fouled!" But our fence was a white picket fence, not chain link; and there was a big yard beyond the fence shaded by an ash tree and another lovely Colorado spruce.

"These images will reward all the attention one can give them. They are a lasting tribute, a most moving picture, of this storied, steel-girded Region."

John Ruff

Cialdella's image, beyond the associations it creates for me personally, provides a sparsely eloquent take on a Northwest Indiana male version of the American dream. It's all there, safe behind a fence with a gate he can lock: his home, his ride, his game. To put it another way, we could think of the court, the car, and the home as a sequence of settings in which an Indiana boy must hold his own as he moves toward manhood. The license plate, dated 1999, historicizes the scene in an interesting way, as it marks the '57 Chevy as a classic. That this icon of Indiana car culture is on a jack, under a slightly Leaning Tower of Basketball, its flag of a net slightly shredded, casts something of a pall over that dream, shrinking it and fencing it in a bit, so as to make it seem somewhat claustrophobic and endangered.

Obviously, what I find so compelling about Cialdella's *Calumet Series* is that he not only gives us the Region as that place where steel was made, where products were manufactured, stored, and shipped, where the nation flexed its great industrial muscles for all the world to see, but he also shows us where people dwelled in this landscape, by showing us their houses, their garages, their yards, their flowerbeds; we see where they shopped, where they worshipped, where they picnicked, and where they played. Recreation is a theme that runs throughout, forming yet another type of juxtaposition that Cialdella excels in capturing. In the foreground of one of my favorite photographs, "Lake Calumet Inlet, Chicago, Illinois, 2002 (closed Acme Steel Coke Plant in dis-

tance)" (page 109), you see a bait bucket, a cooler, a Weber grill, a lawn chair, and a fishing pole on the weedy bank of a tiny river or cove. Nothing else is needed for the imagination to conjure the absent fisherman (absence, in fact, is ever-present in these images). There are actually three absent fishermen here, the others suggested by two more lawn chairs left up the shore, facing in the opposite direction, suggesting that we are on a peninsula. More than the strange choreography of abandoned lawn chairs and fishing equipment, it is the jagged sawtooth outline of smokestacks and factories on the distant horizon that unsettles the scene, the upper half of which is dominated by a leaden sky.

Cialdella often splits an image between the idyllic foreground and the industrial background, between play and work, sometimes on a straight horizontal axis, sometimes on a diagonal. In one of my favorite photos, "Calumet Park Beach, Chicago, 2003" (page 110), a family sprawls on a Lake Michigan beach with a power plant looming in the background down the shore. There are several beach recreation scenes in the series that remind me of Dudley paintings, but they are darker, and the industrial background is more ominous and somehow threatening. In what for me is one of his most iconic Indiana South Shore Un-Posters, Cialdella juxtaposes an empty outdoor basketball court, just a rectangular slab of concrete with a backboard planted in it, against a set of four huge refinery tanks ("Amoco Park, Hammond, Indiana, 1989," frontispiece). More than half of the image is gray sky, with power lines strung across it, suggesting to me an empty musical score. A few short evergreens

outlined against one of the tanks are the only evidence that this is not the moon or Saudi Arabia, but Indiana. There is also a photograph of the empty ball field; you could call it "No Field of Dreams" or "Field of Dreams Deferred." Plainspoken Gary Cialdella calls it "Baseball Field, Whiting Park, Whiting, Indiana, 1999 (East Chicago steel mills in distance)" (page 62), and that's what we see: the right side of an infield and right field beyond it, shot through the backstop, with the East Chicago mills at a distance breaking the horizon— another evocative use of chain link fencing, a part of the visual vocabulary of this series that I need more time to think about. And while I'm at it, there are carnival scenes to consider, where the fun is clearly over, the machinery waiting to be hauled away.

Cialdella creates great visual poetry of empty streets and empty parking lots, of billboards and the undersides of overpasses. These images will reward all the attention one can give them. They are a lasting tribute, a most moving picture, of this storied, steel-girded Region.

PHOTOGRAPHS

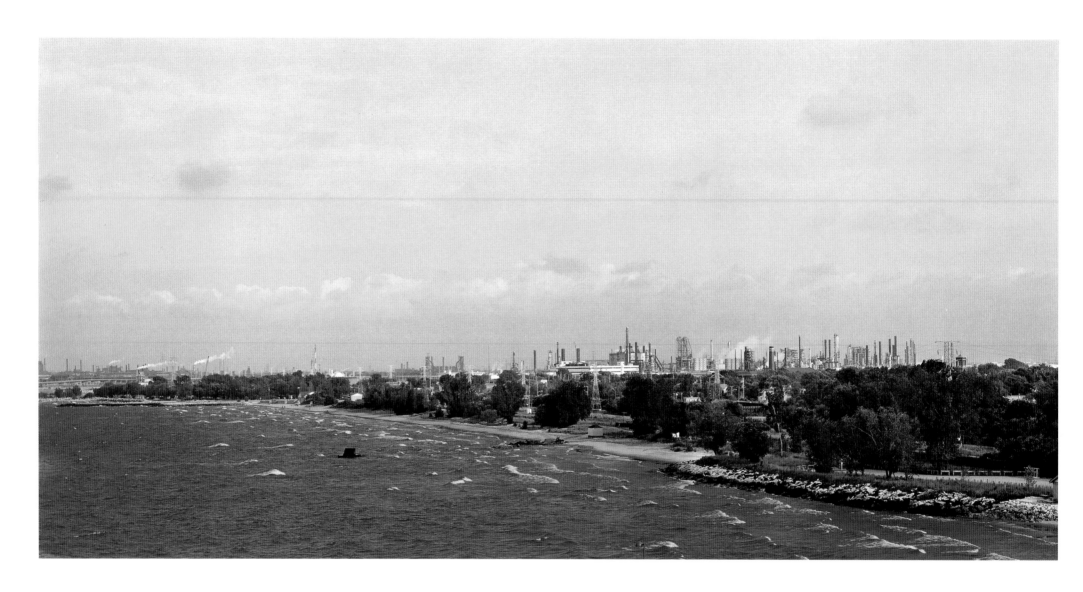

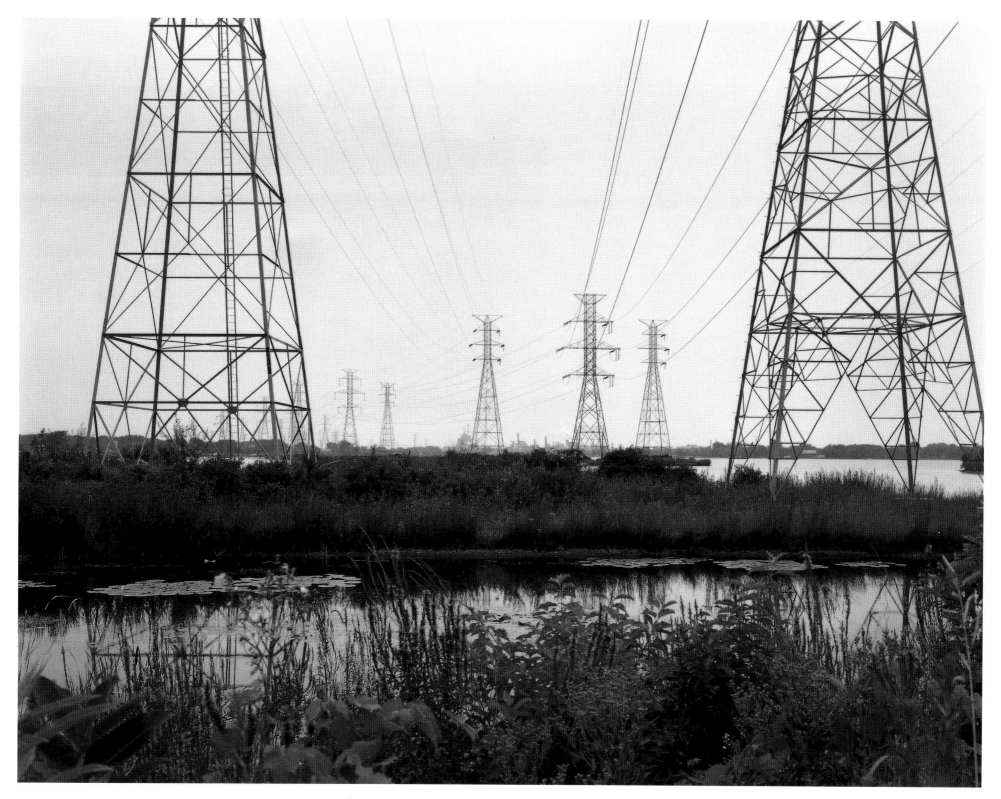

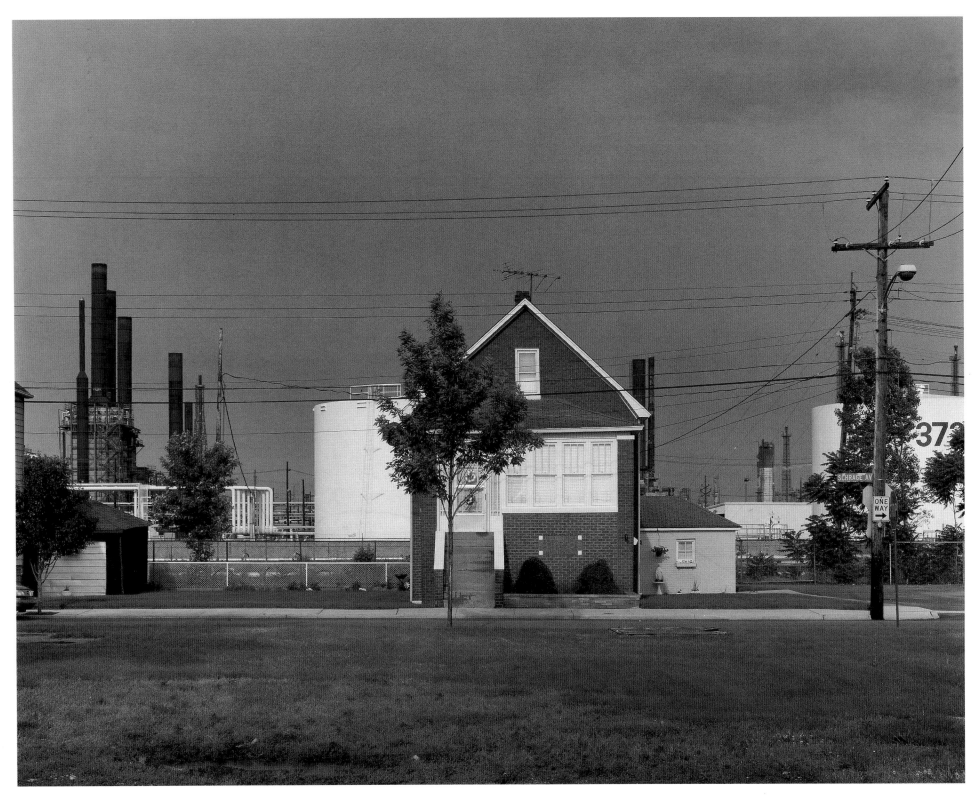

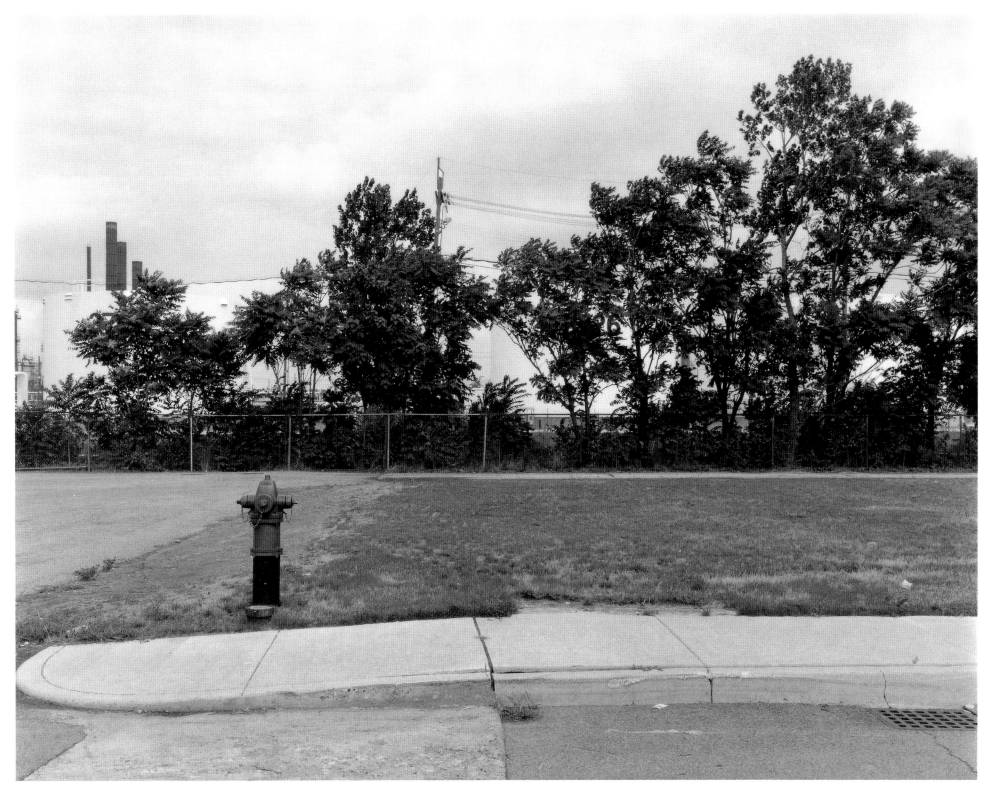

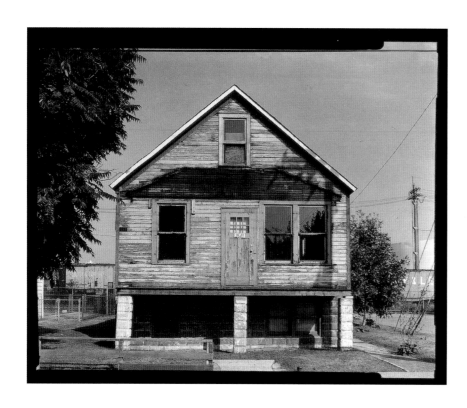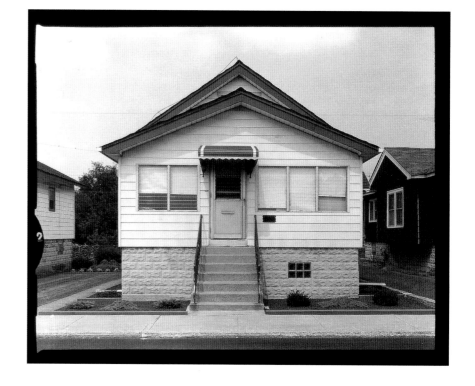

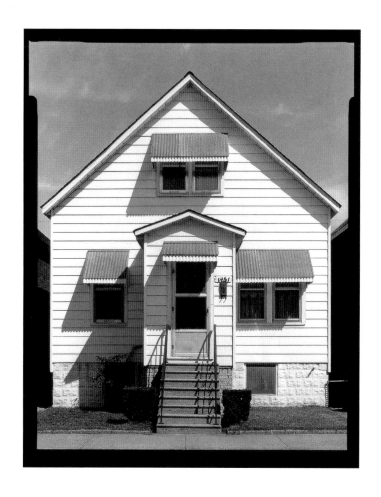

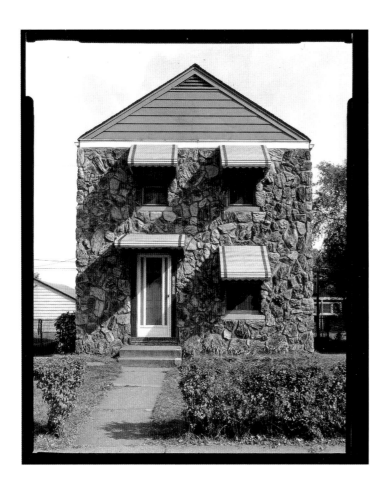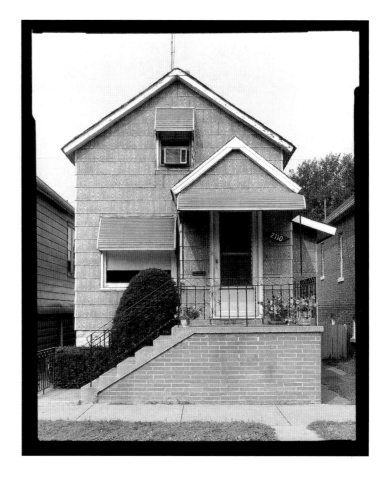

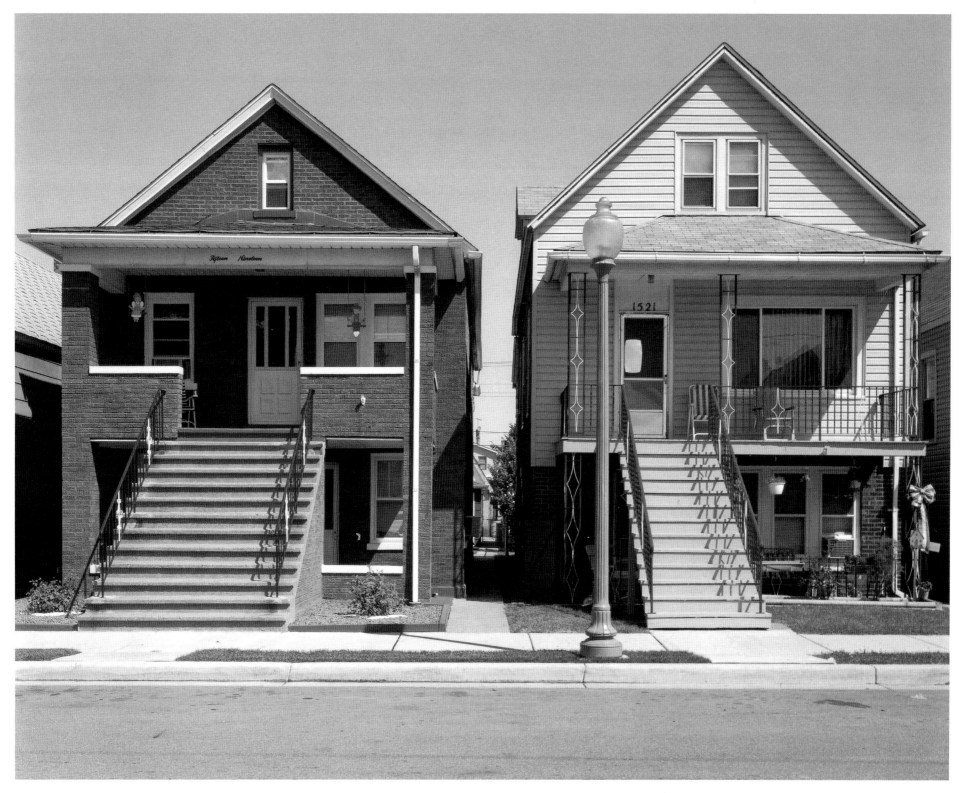

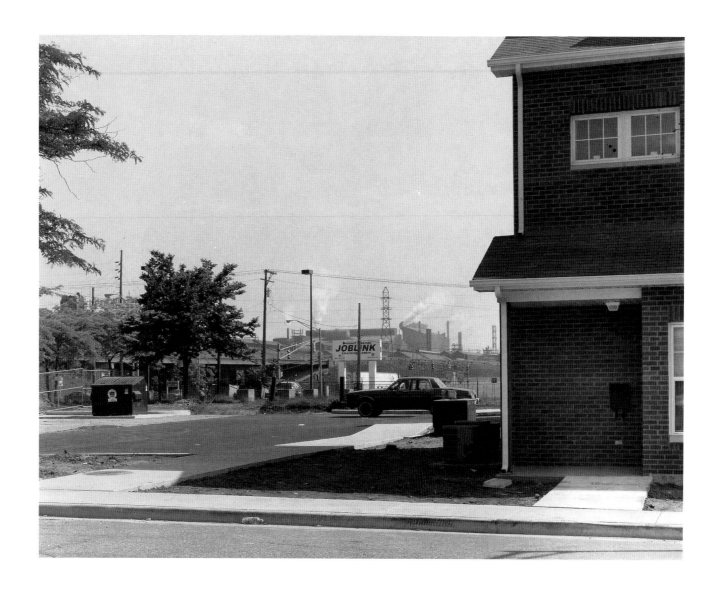

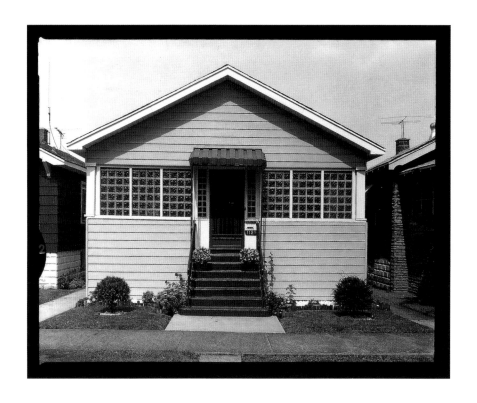

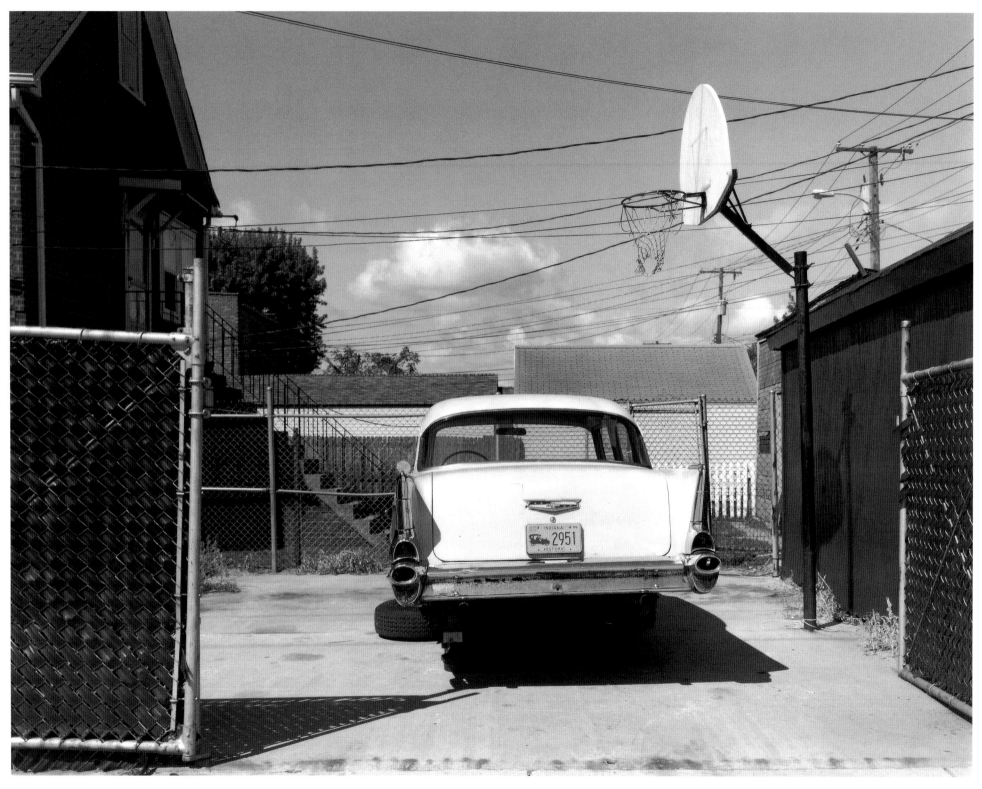

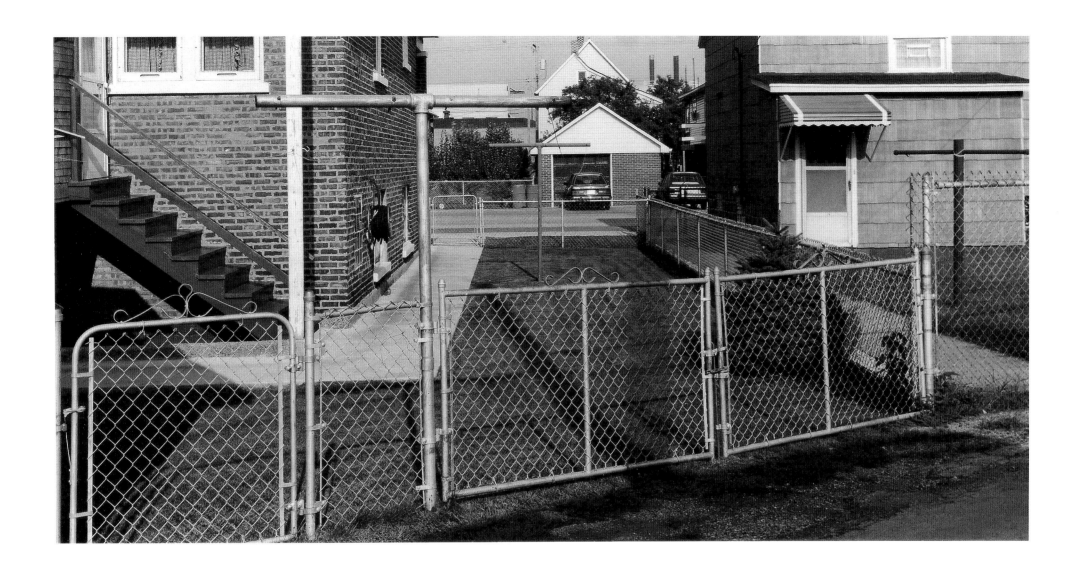

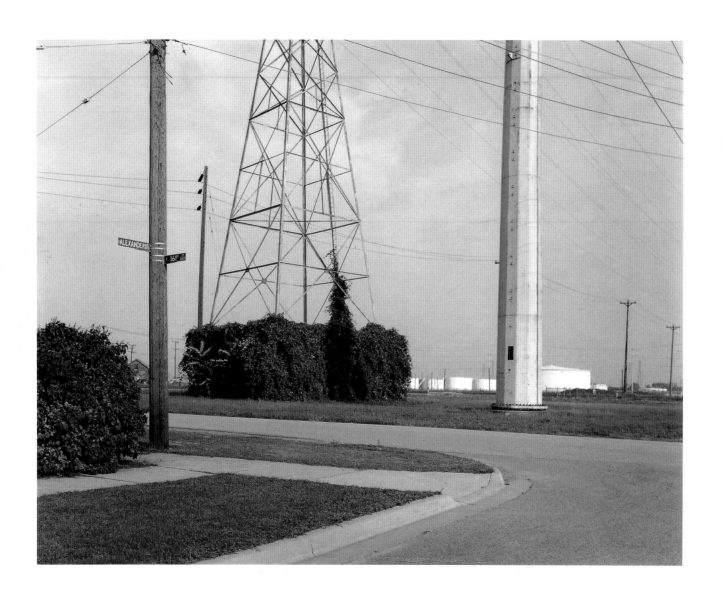

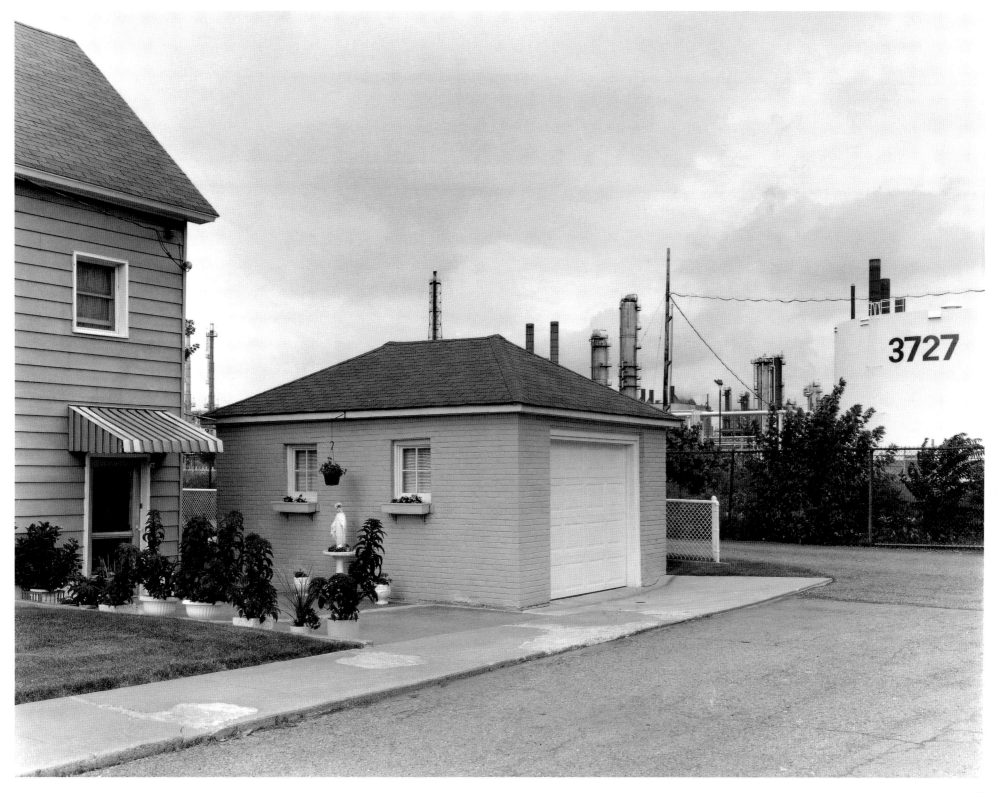

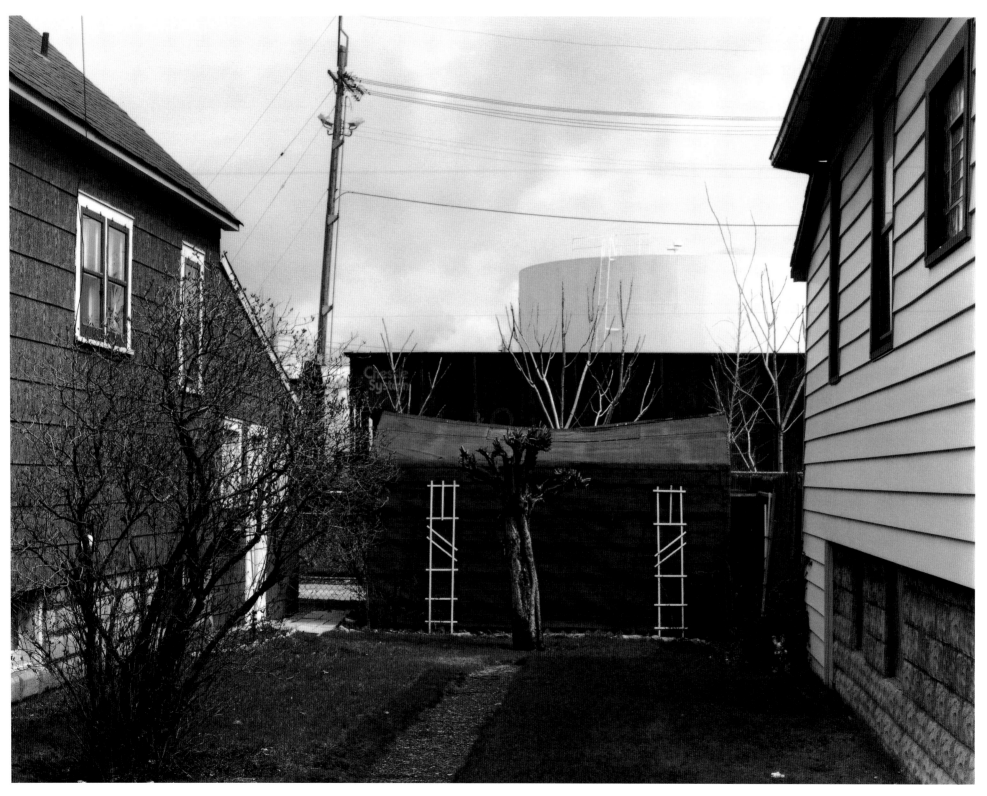

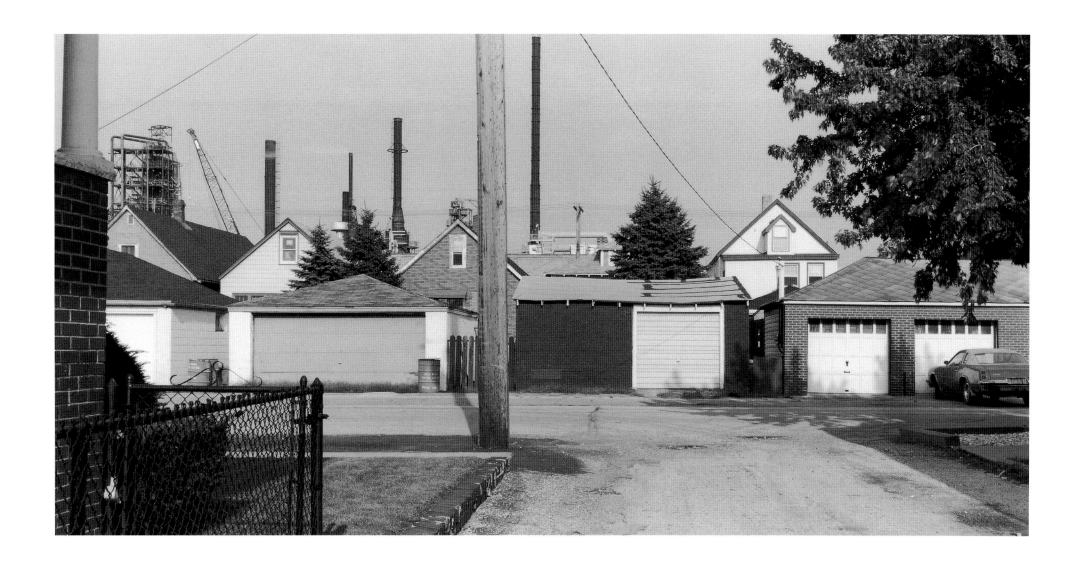

Steel mills line the shore.
Childhood memories of the
An American place.

old neighborhood.

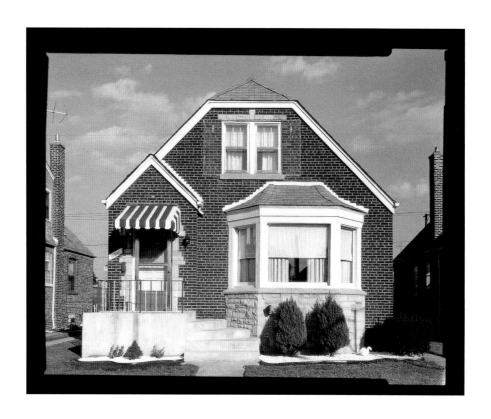

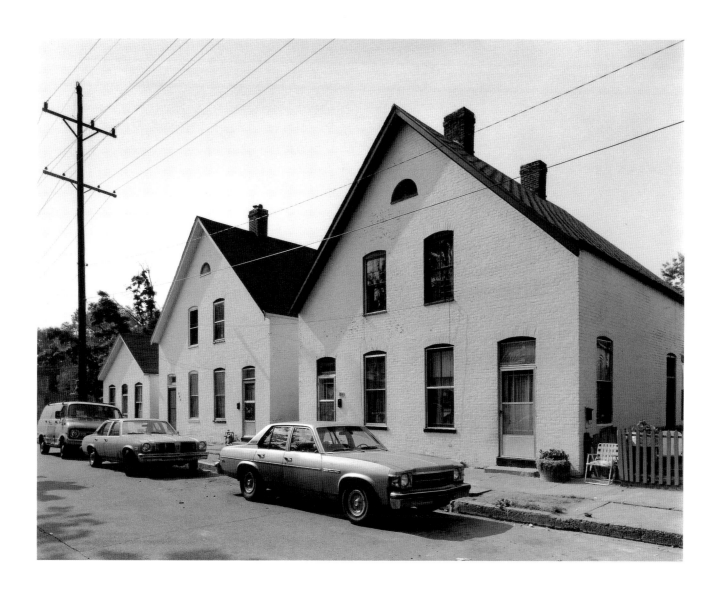

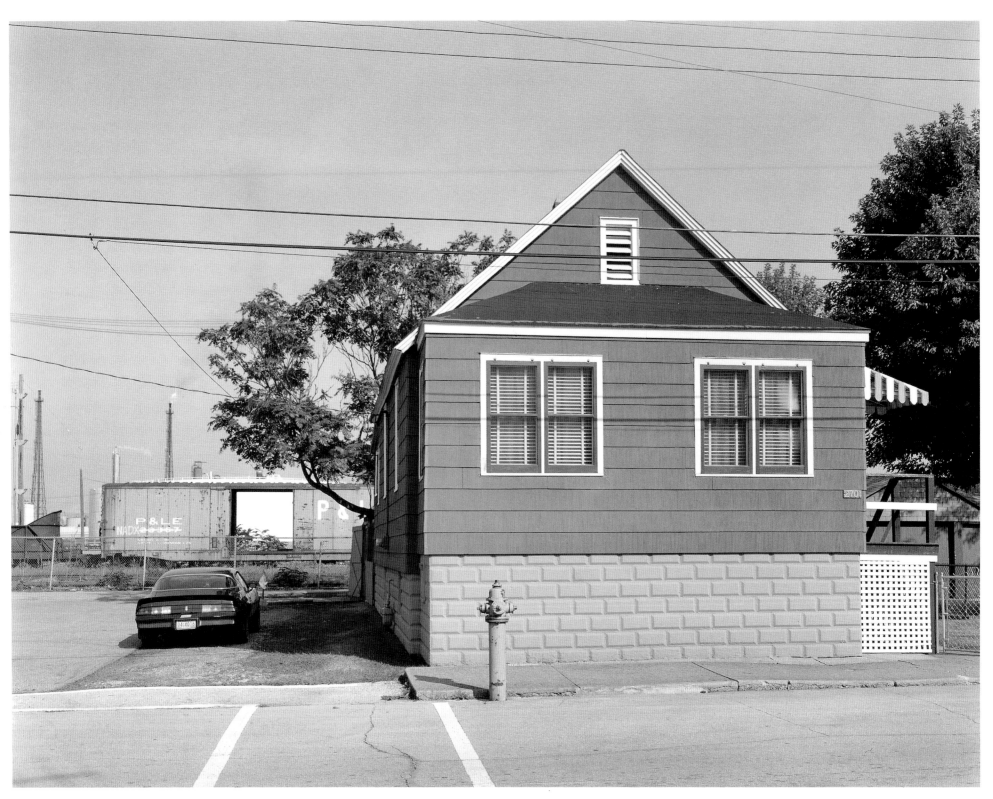

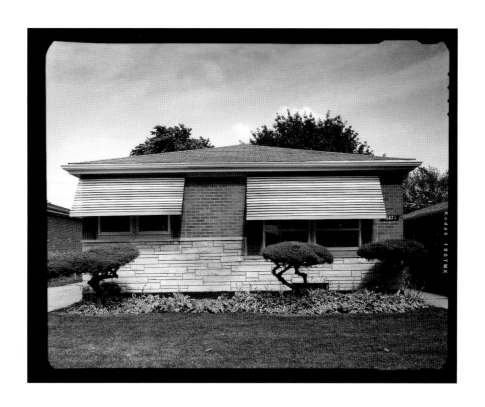

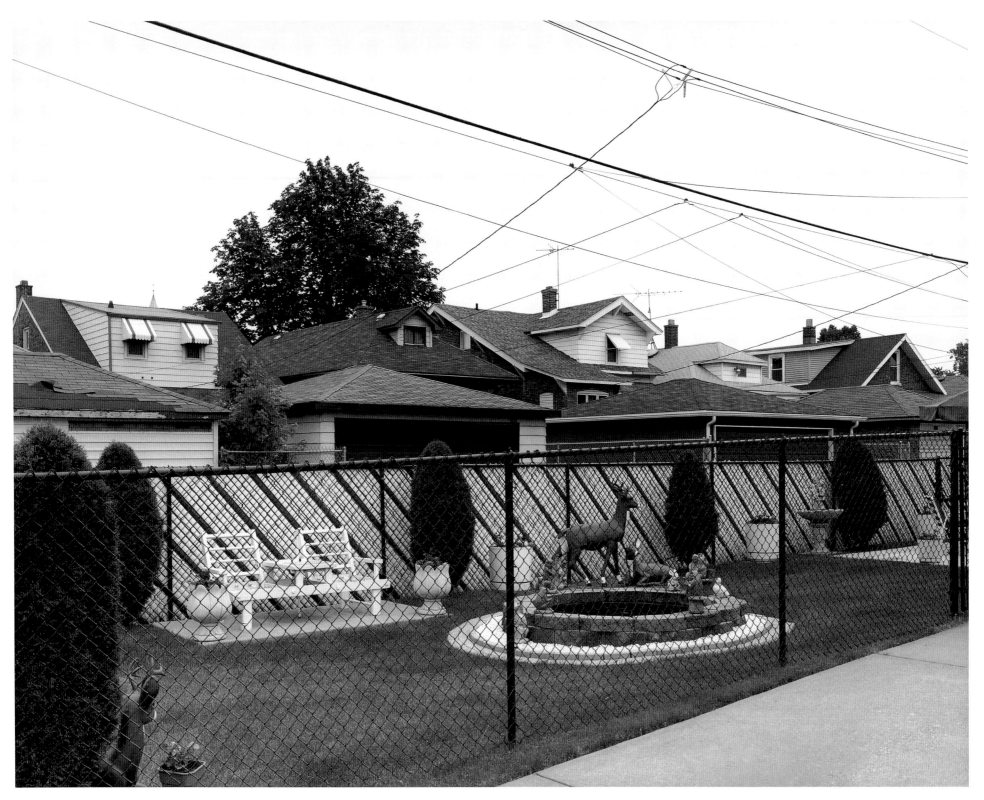

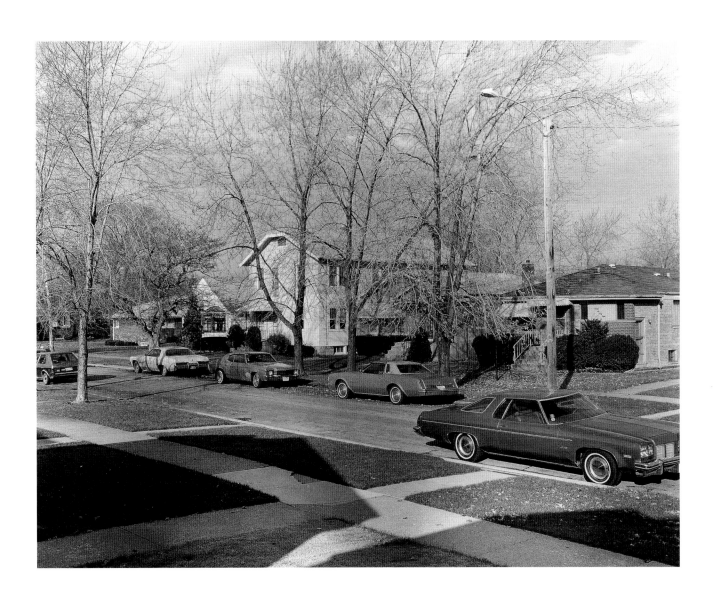

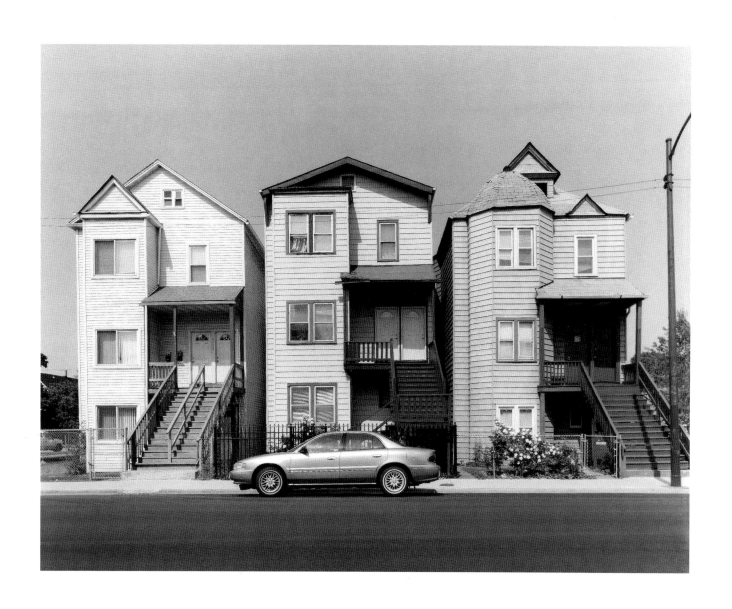

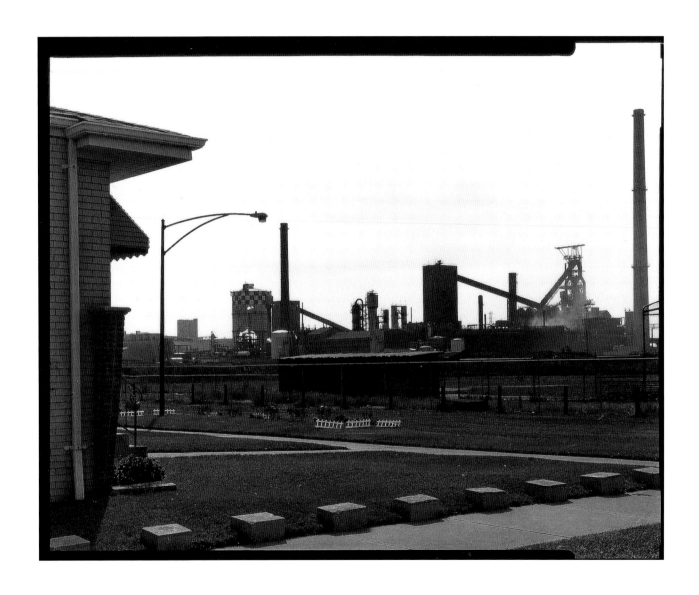

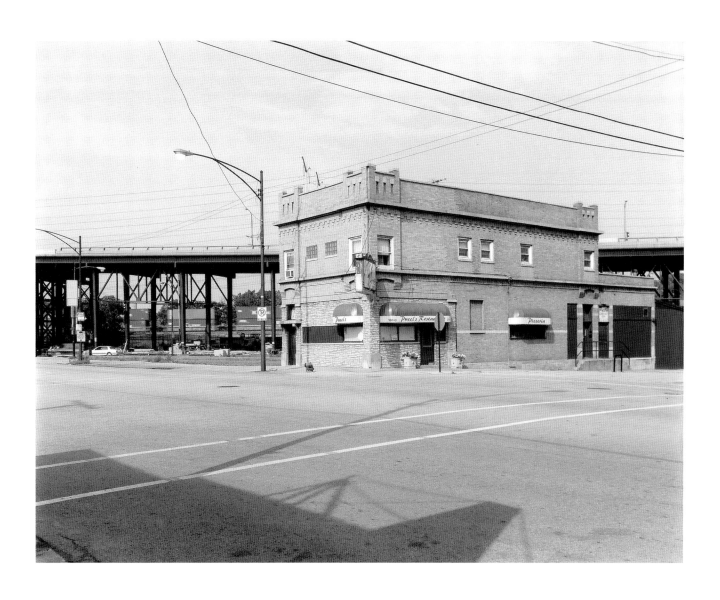

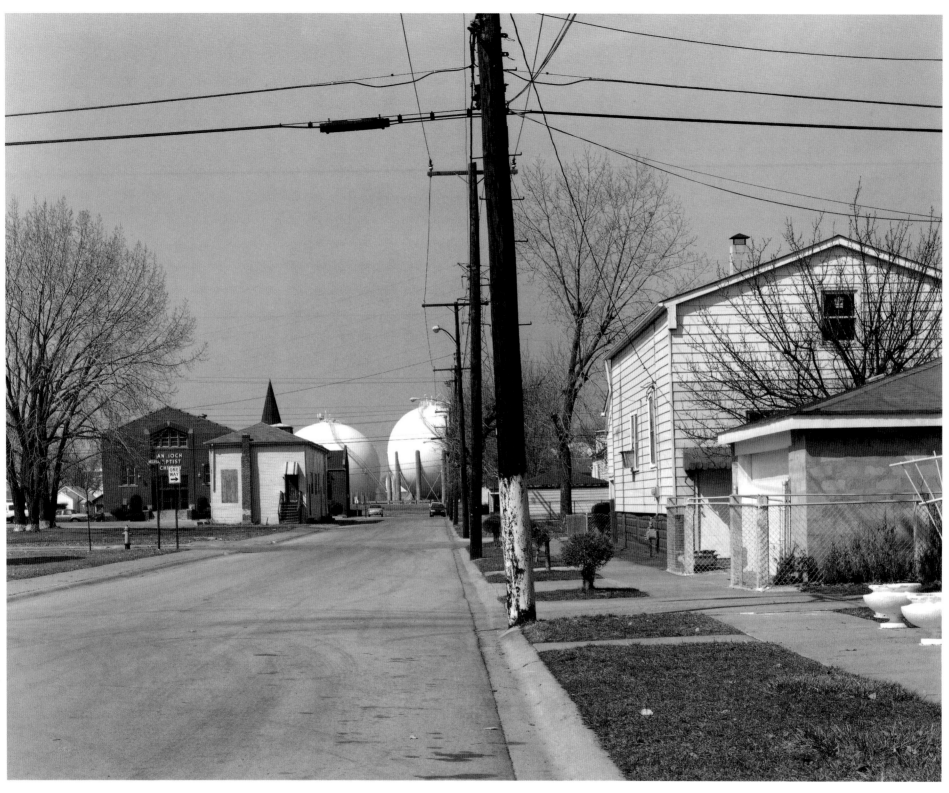

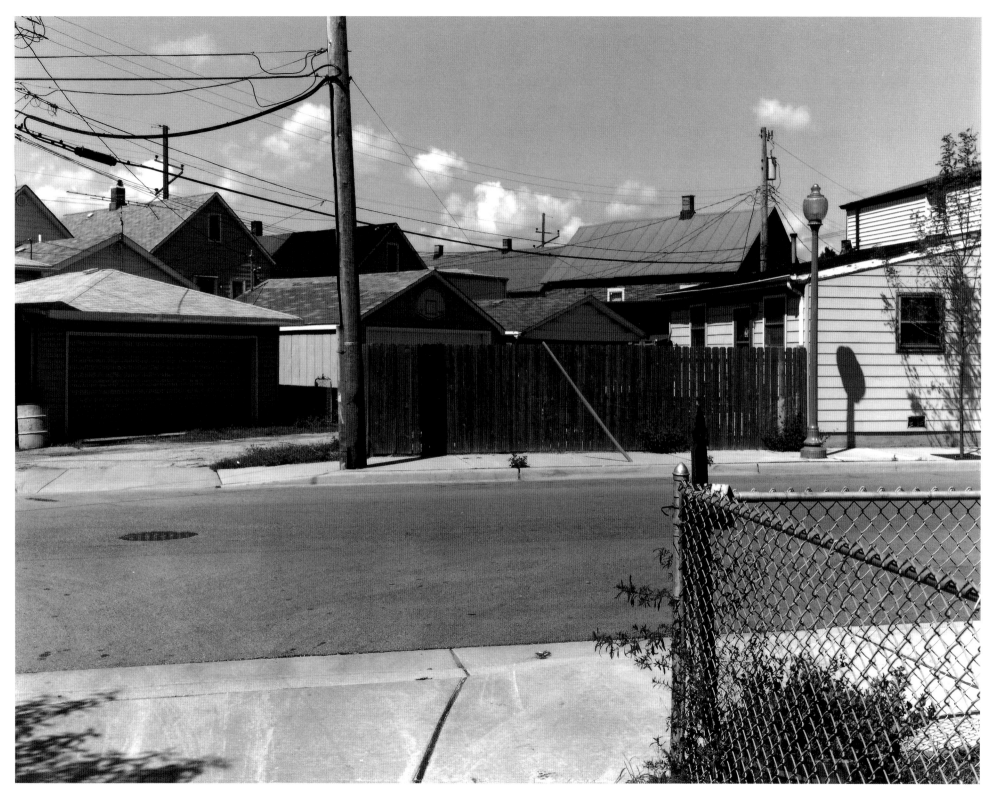

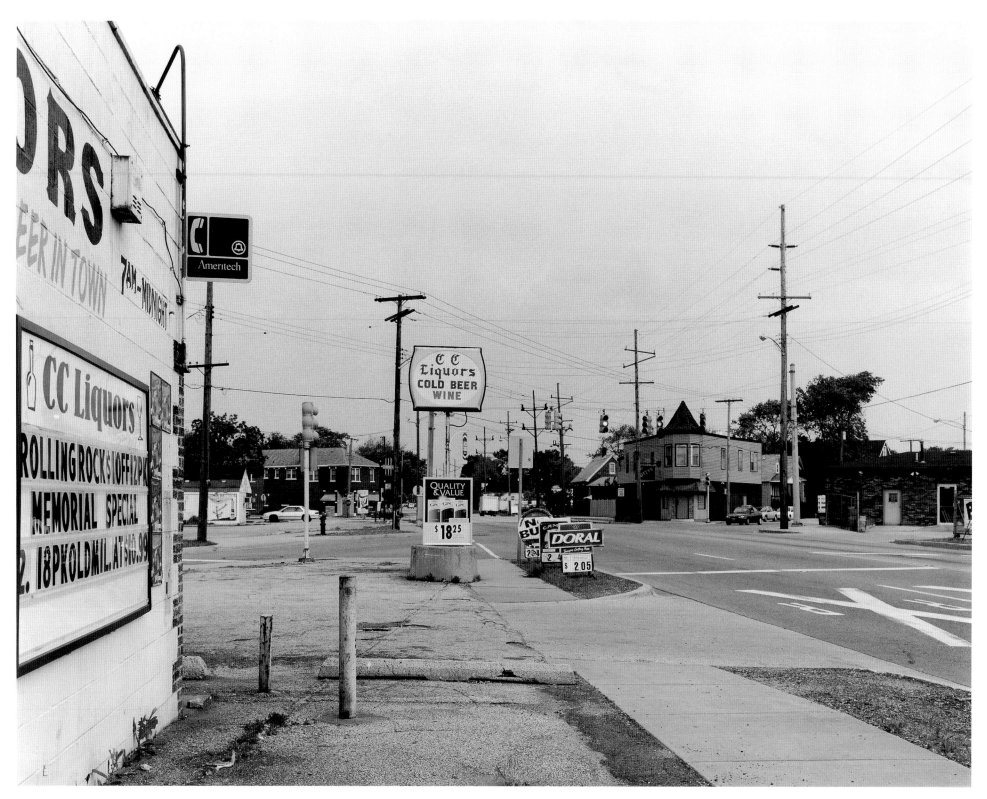

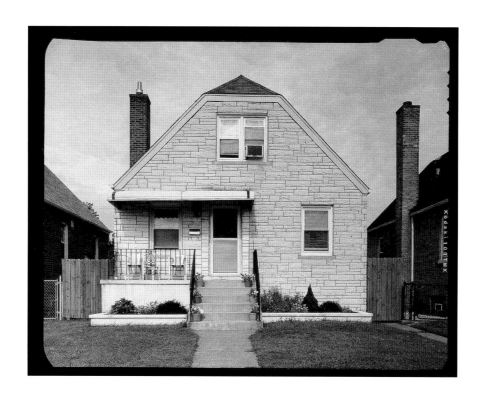

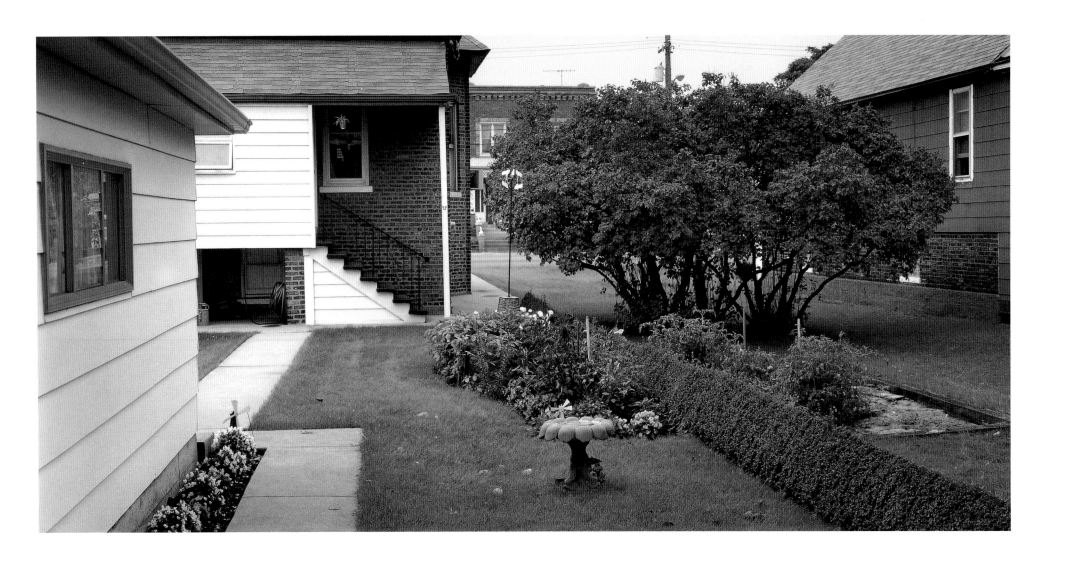

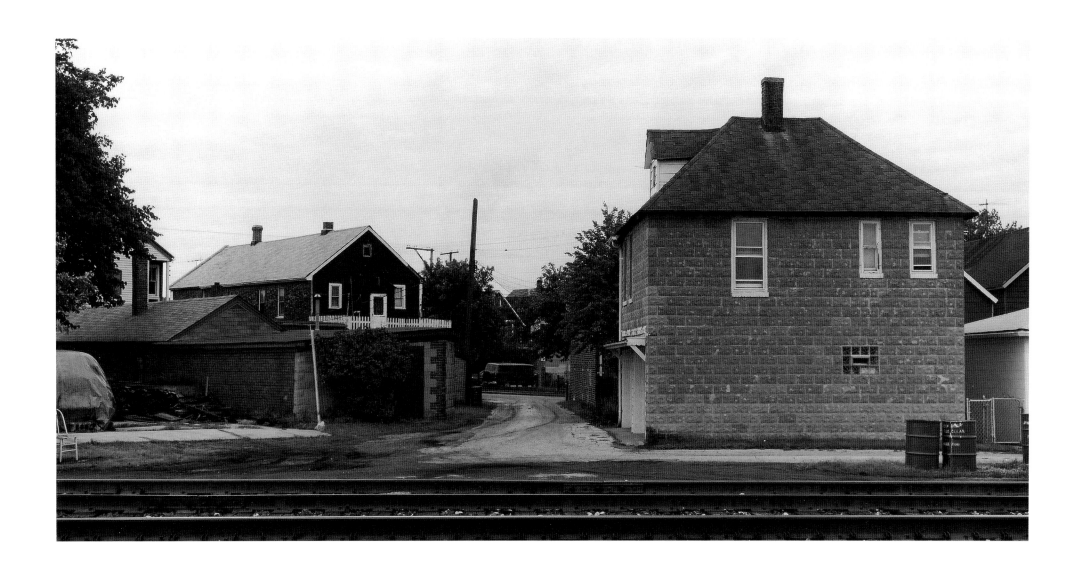

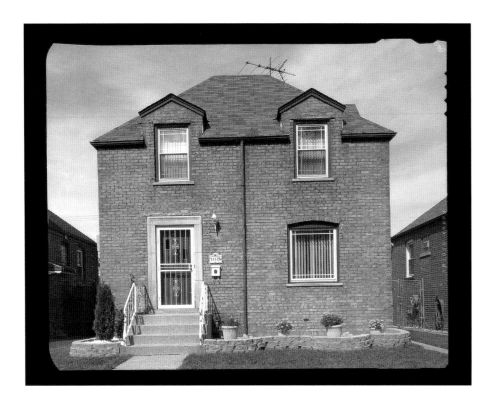 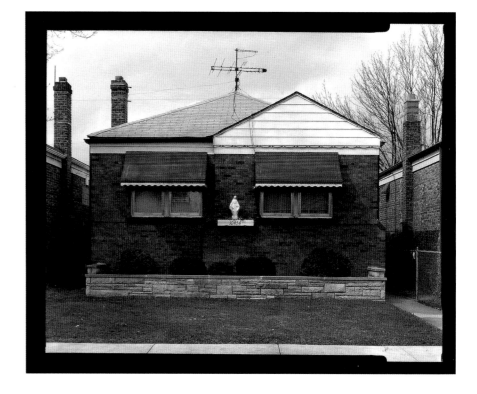

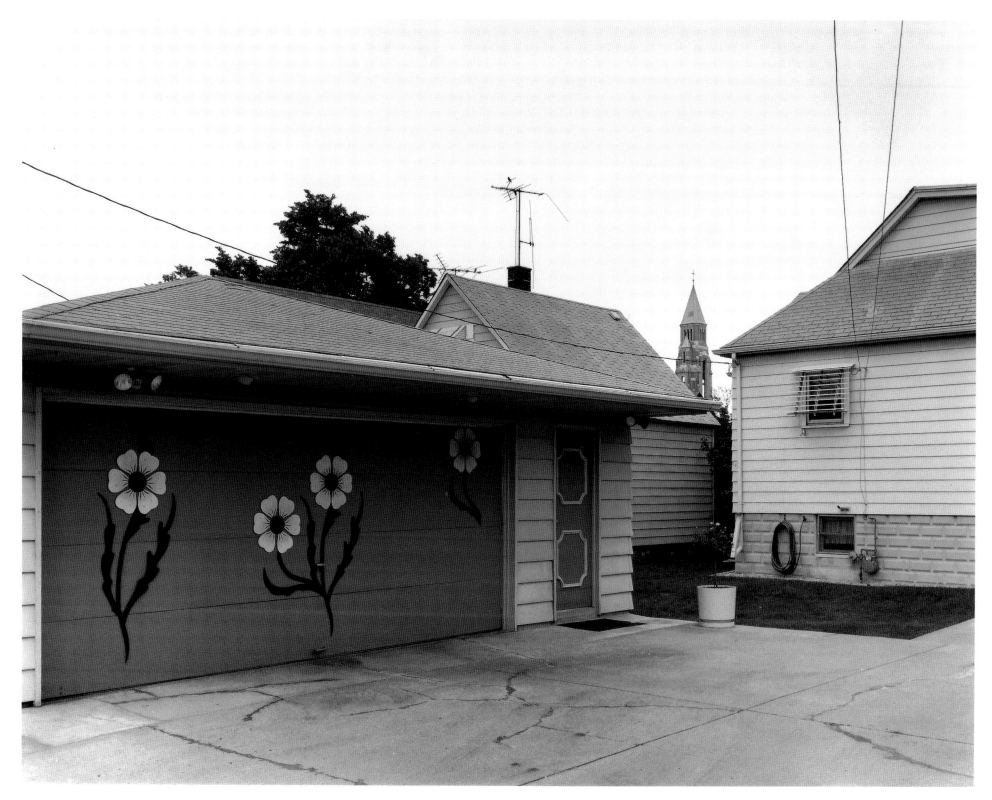

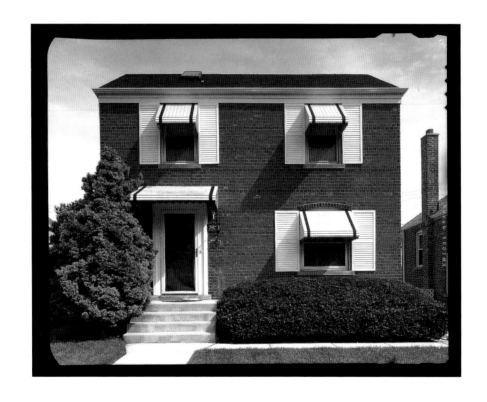

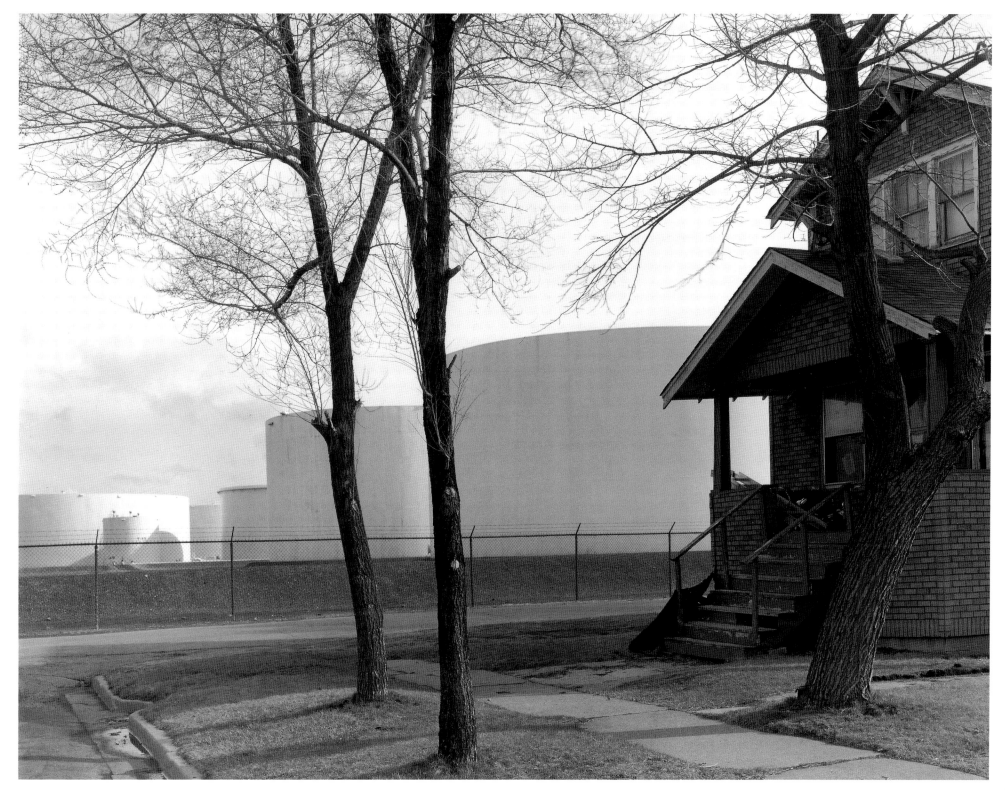

DOLTON

INDUS

CROSSROADS

BURNHAM SKY LANSING

BLUE ISLAND HEAT RIVER BORDER

REFINERY

TRY

ILLINOIS

SKYWAY

HAMMOND

GARY

WHITING

HEGEWISCH

STEEL

INDIANA

EAST CHICAGO

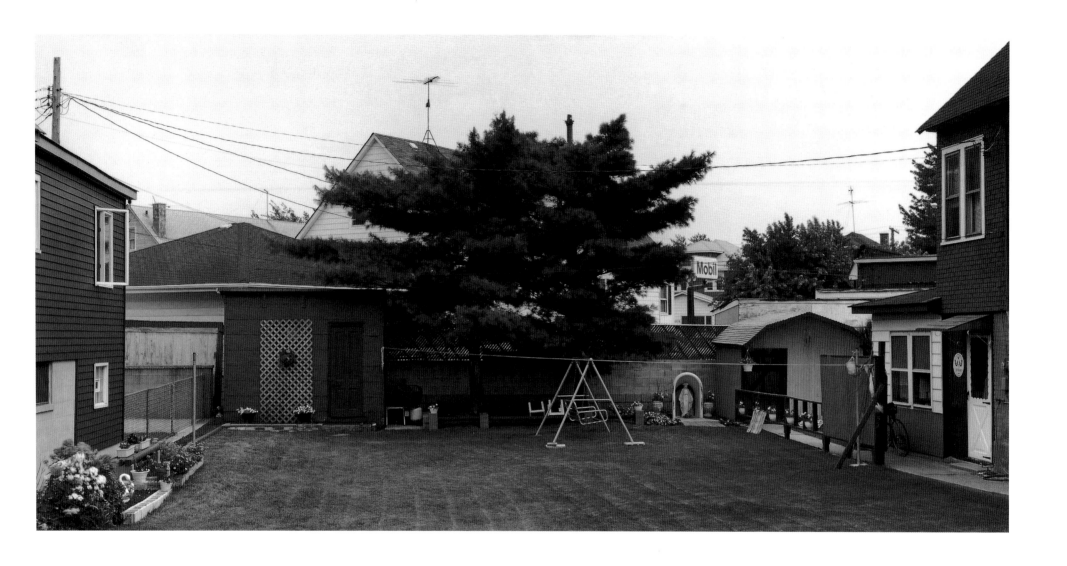

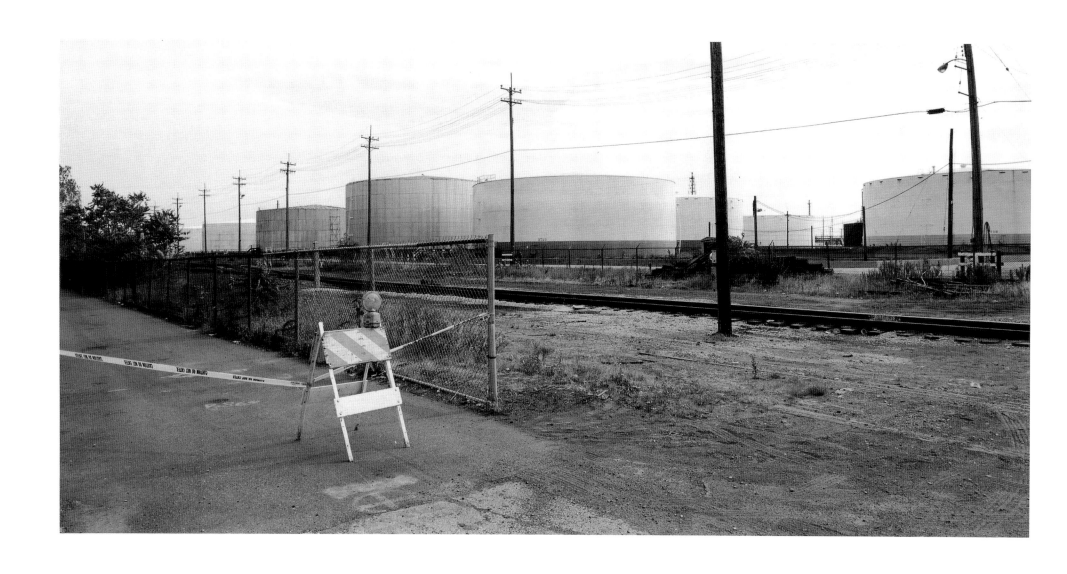

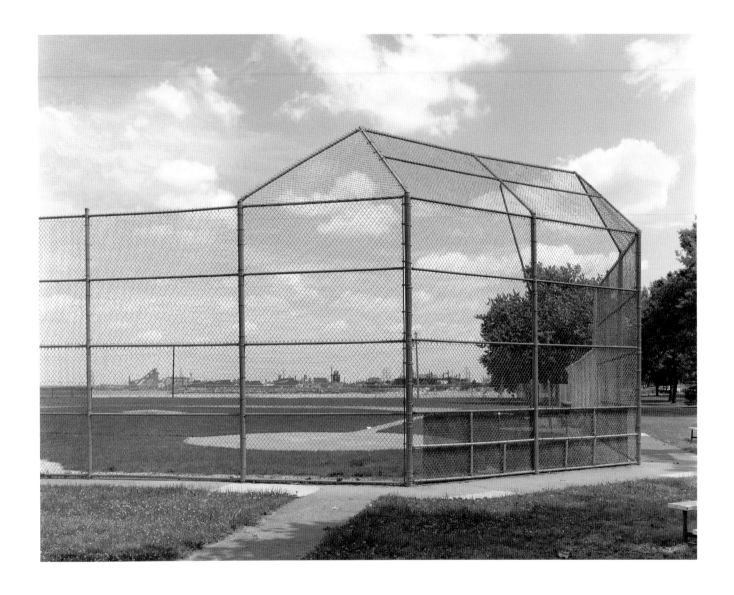

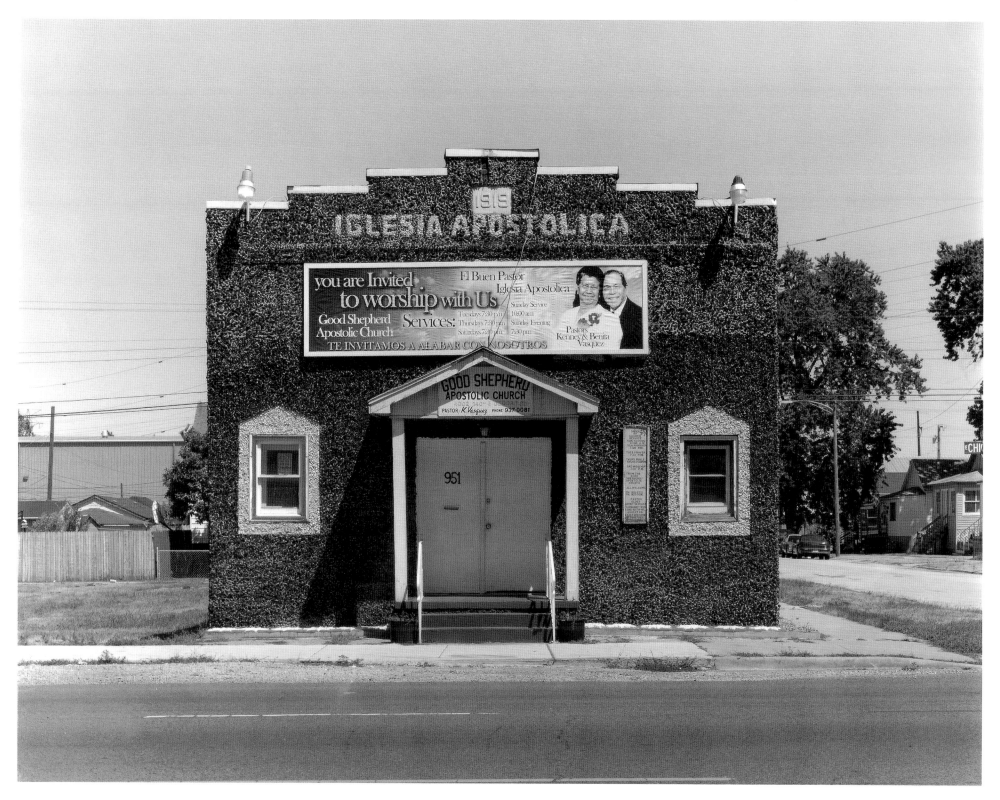

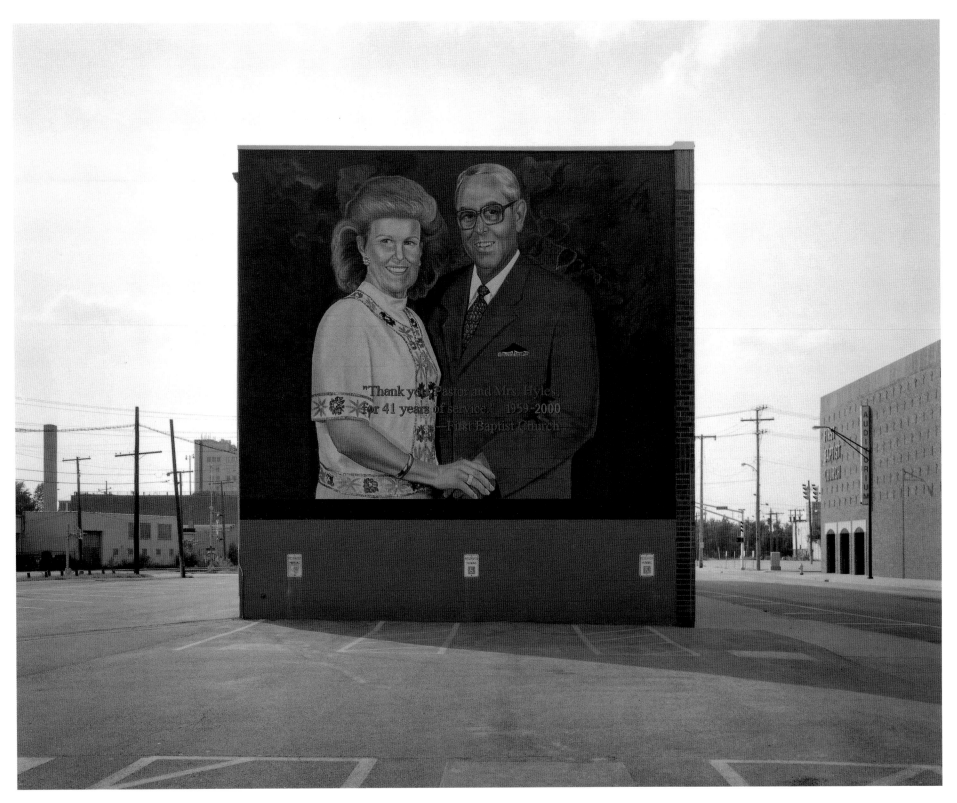

"Thank you, Pastor and Mrs. Hyles, for 41 years of service!" 1959-2000
—First Baptist Church

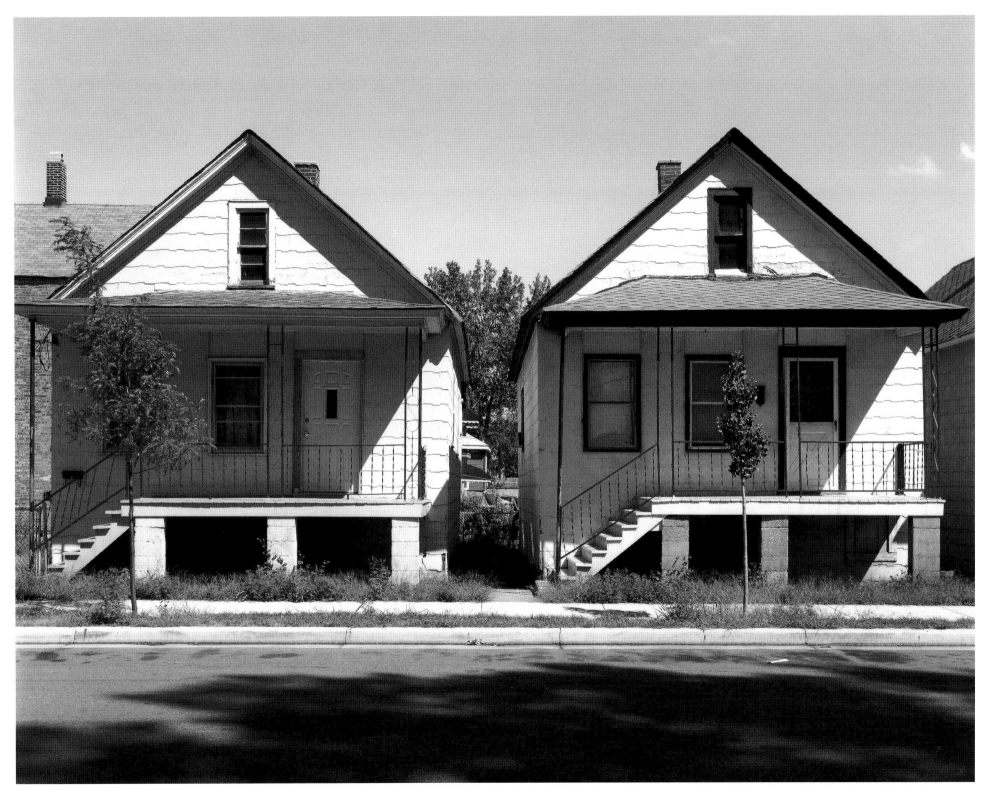

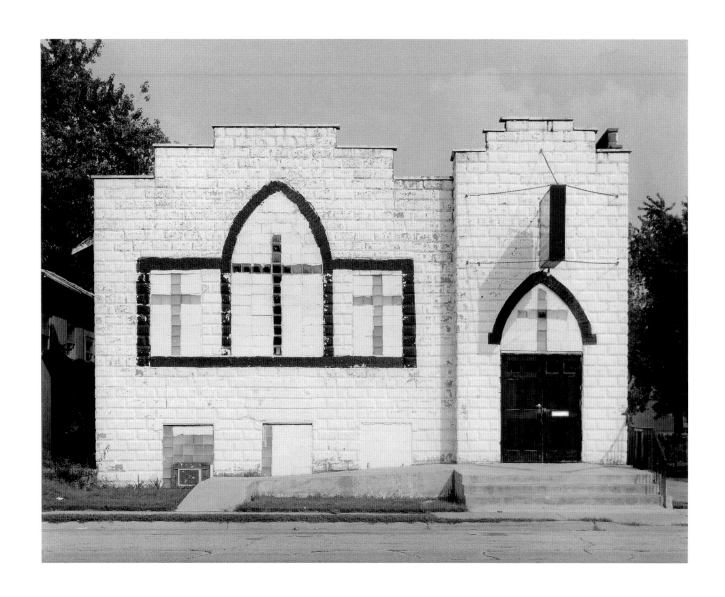

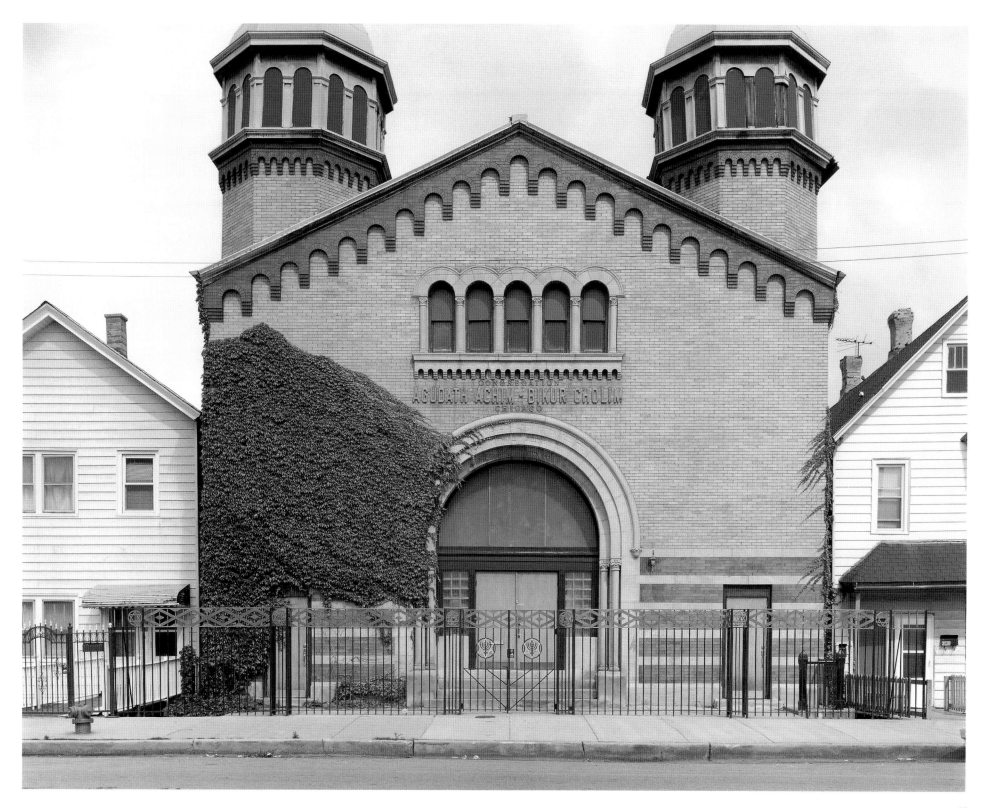

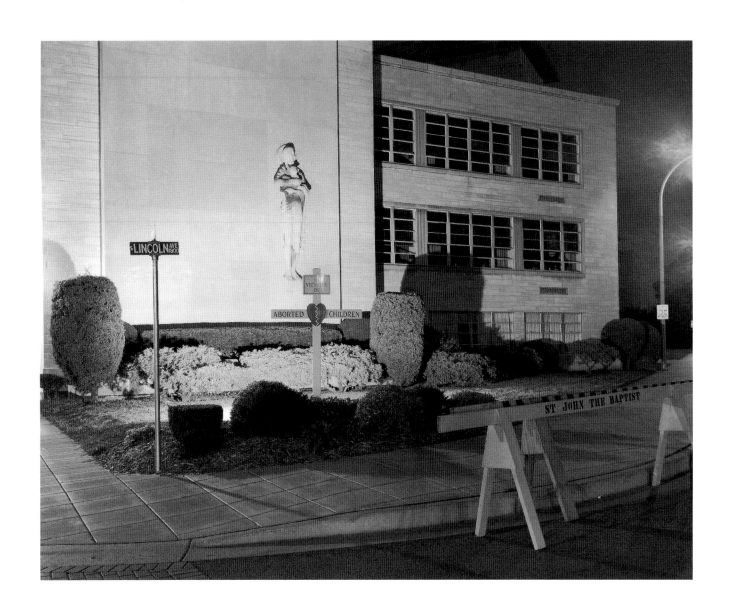

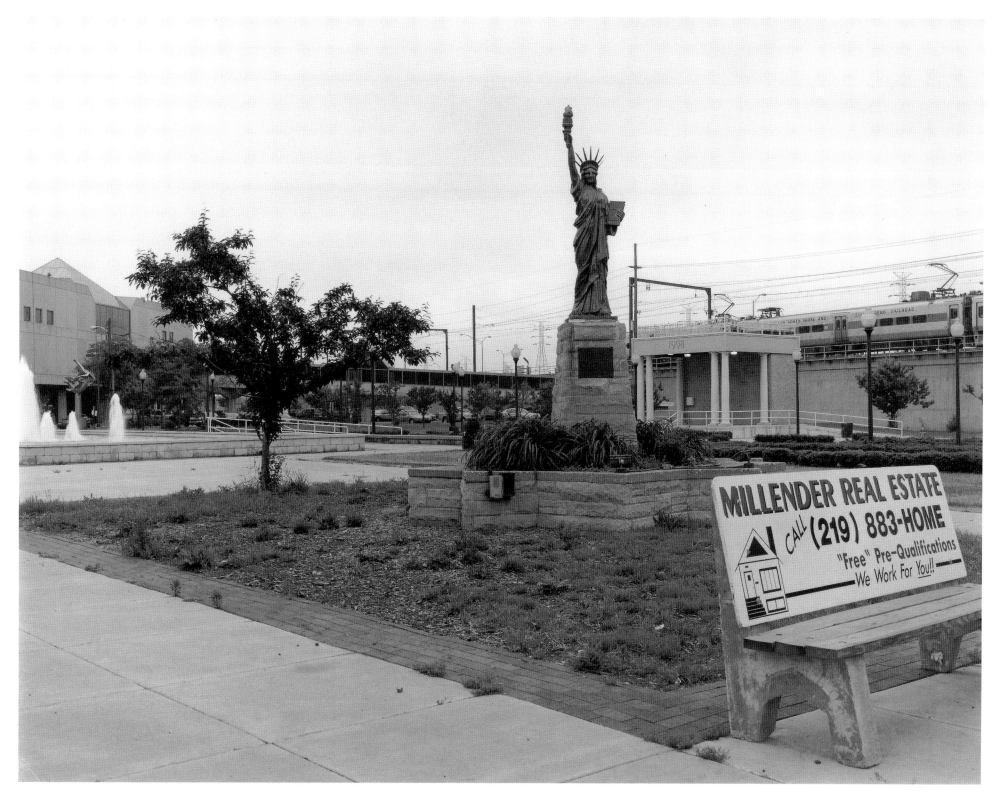

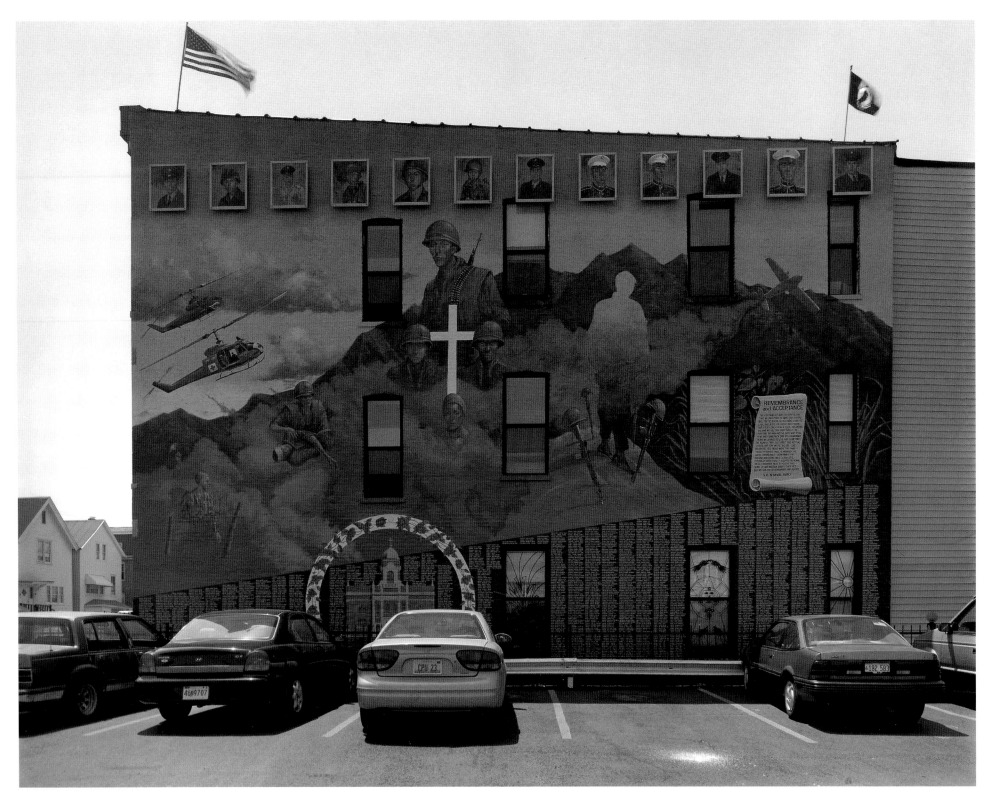

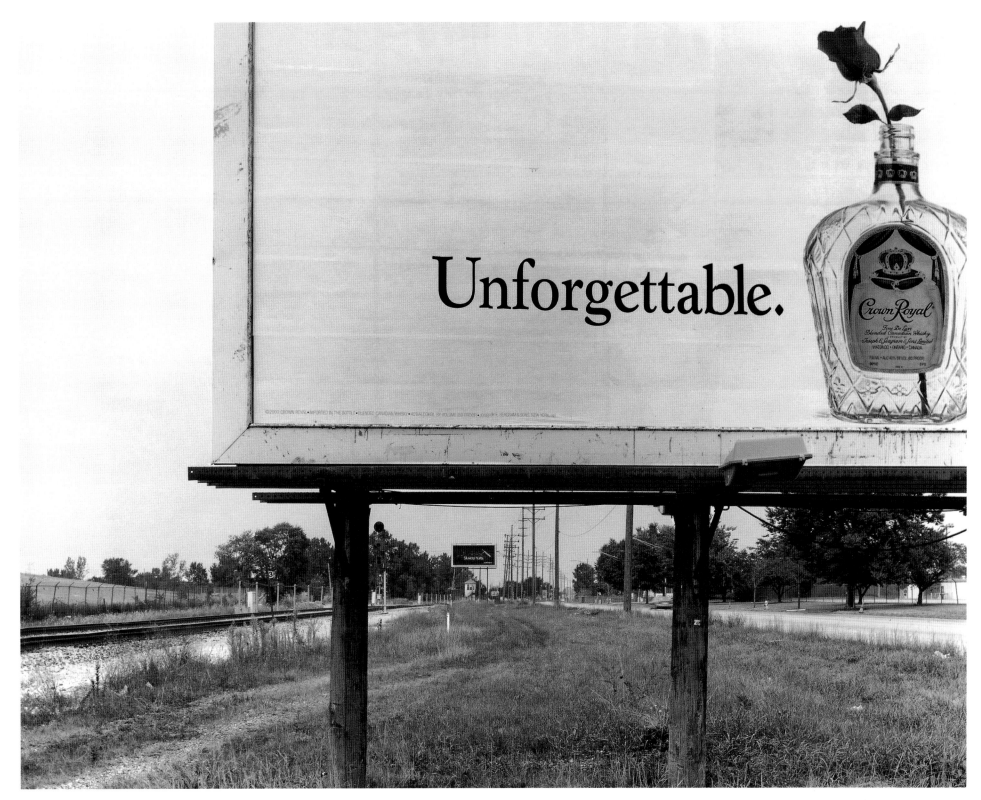

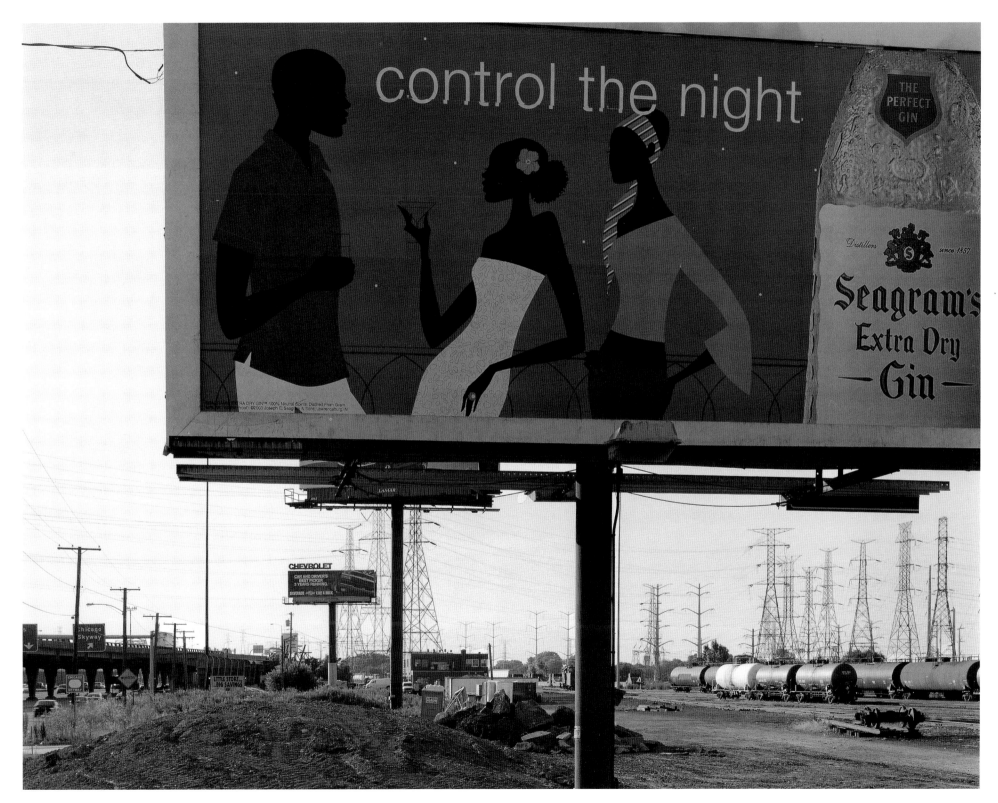

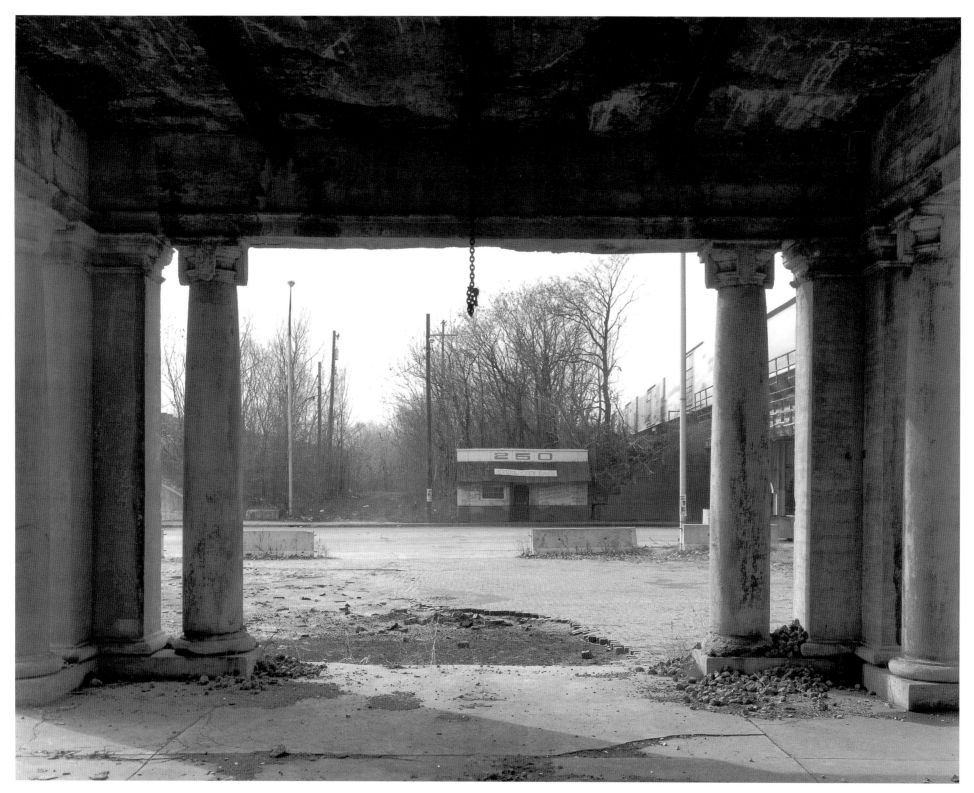

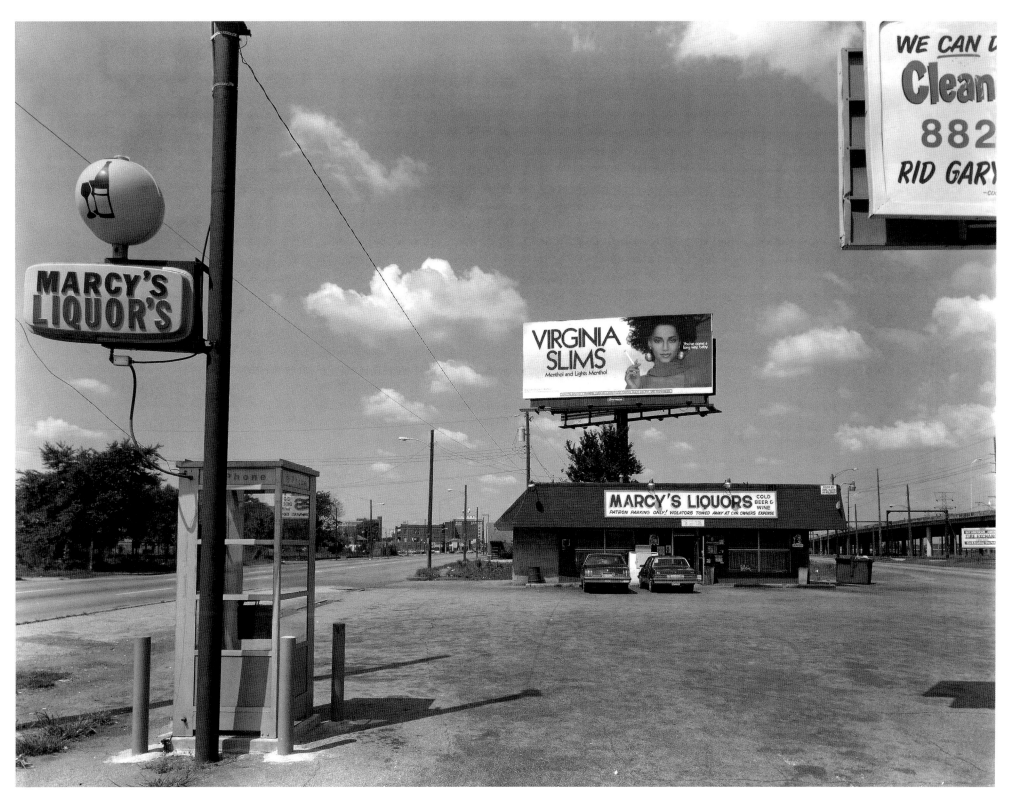

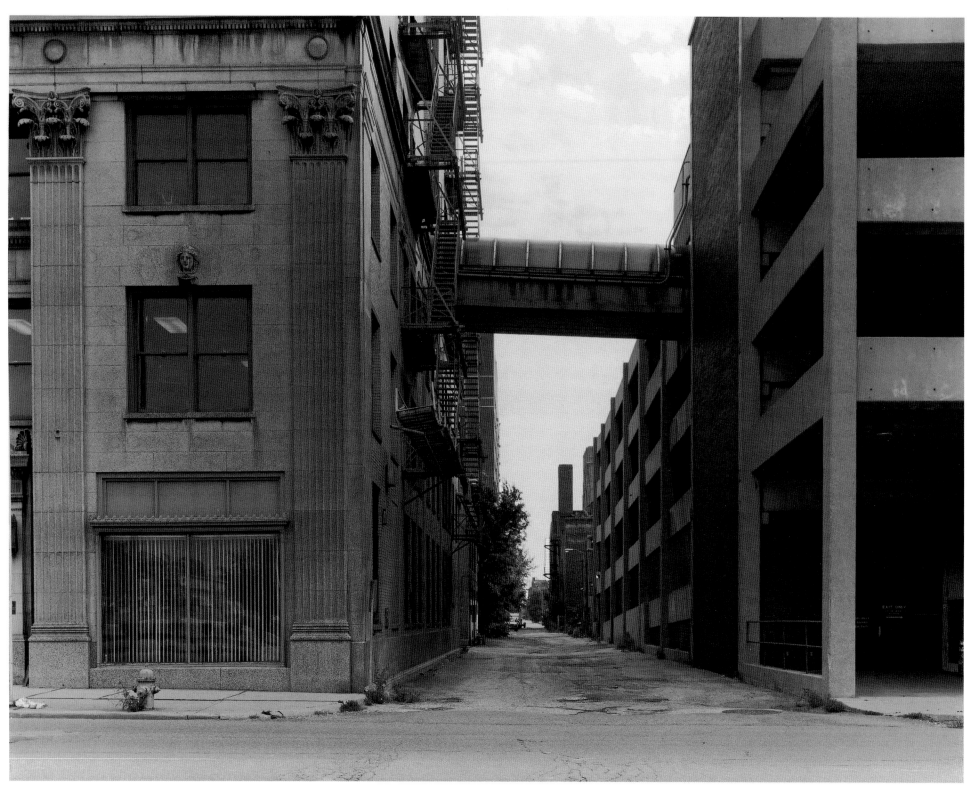

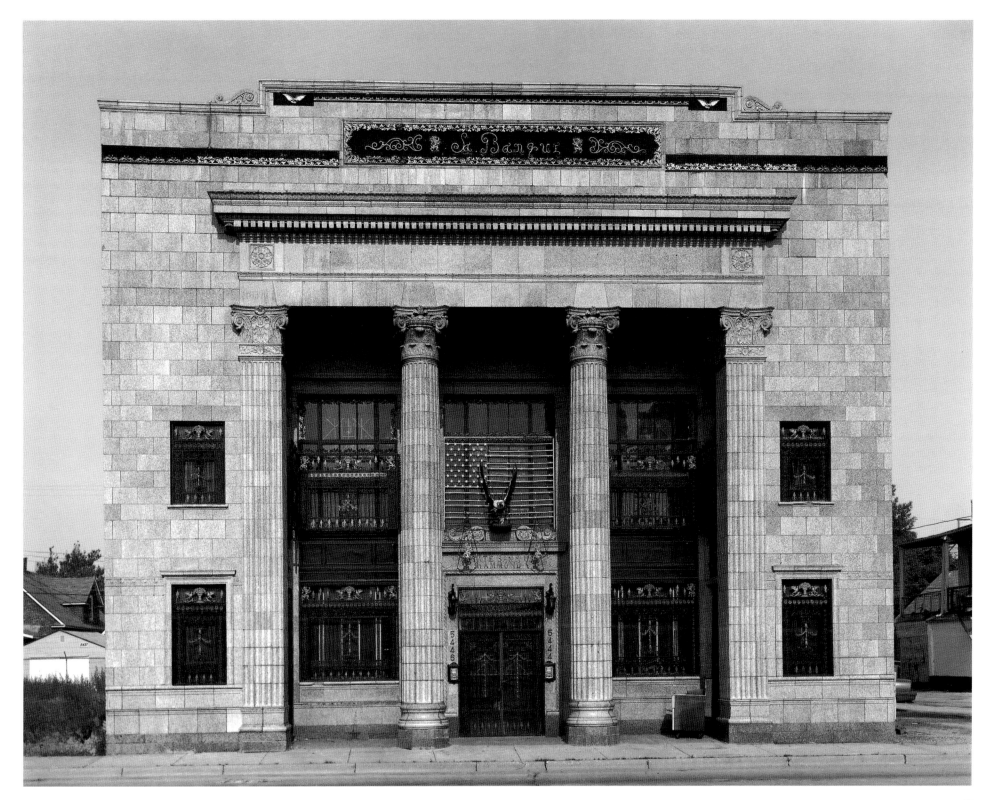

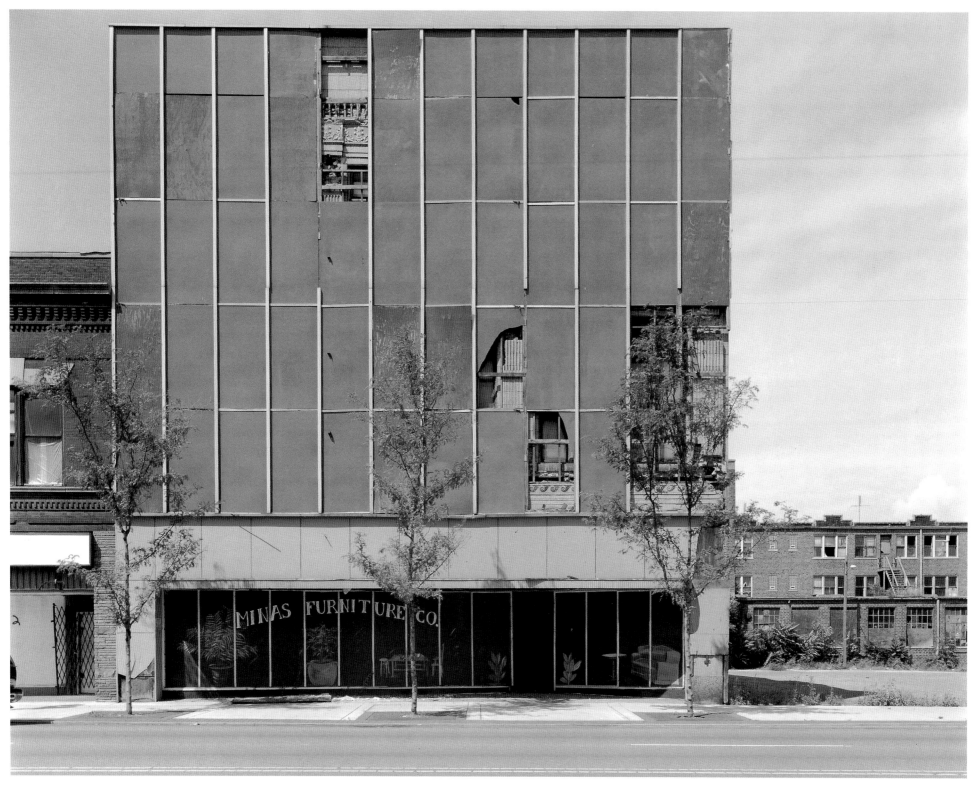

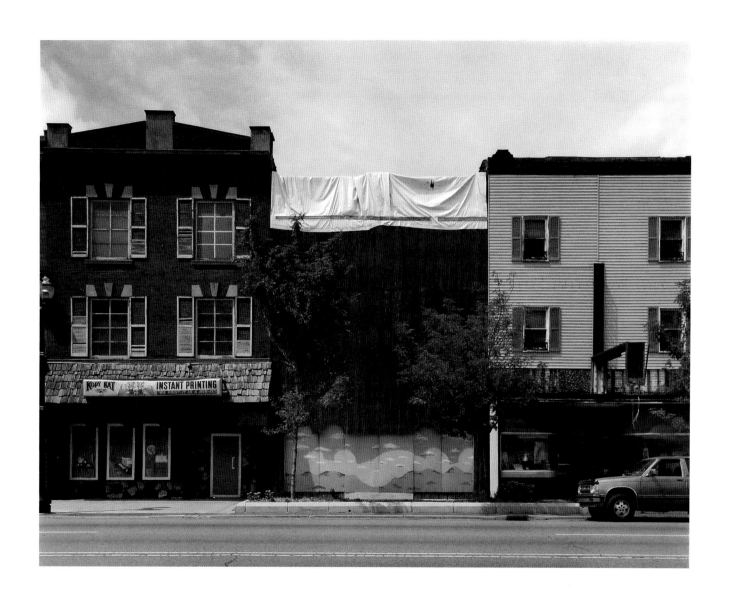

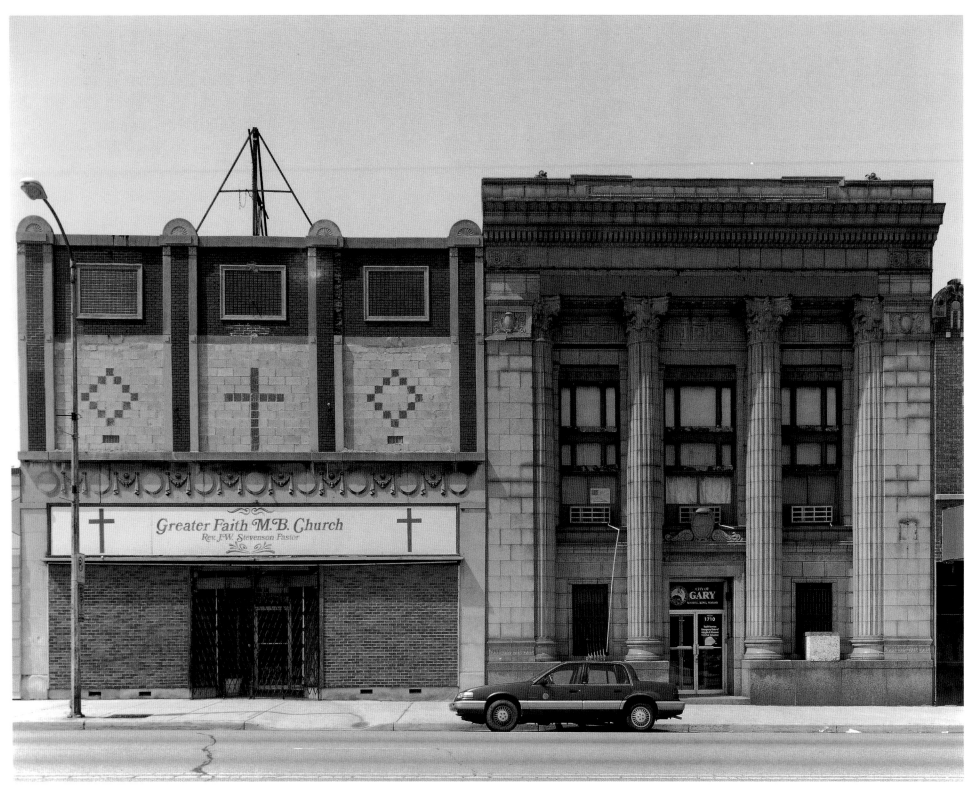

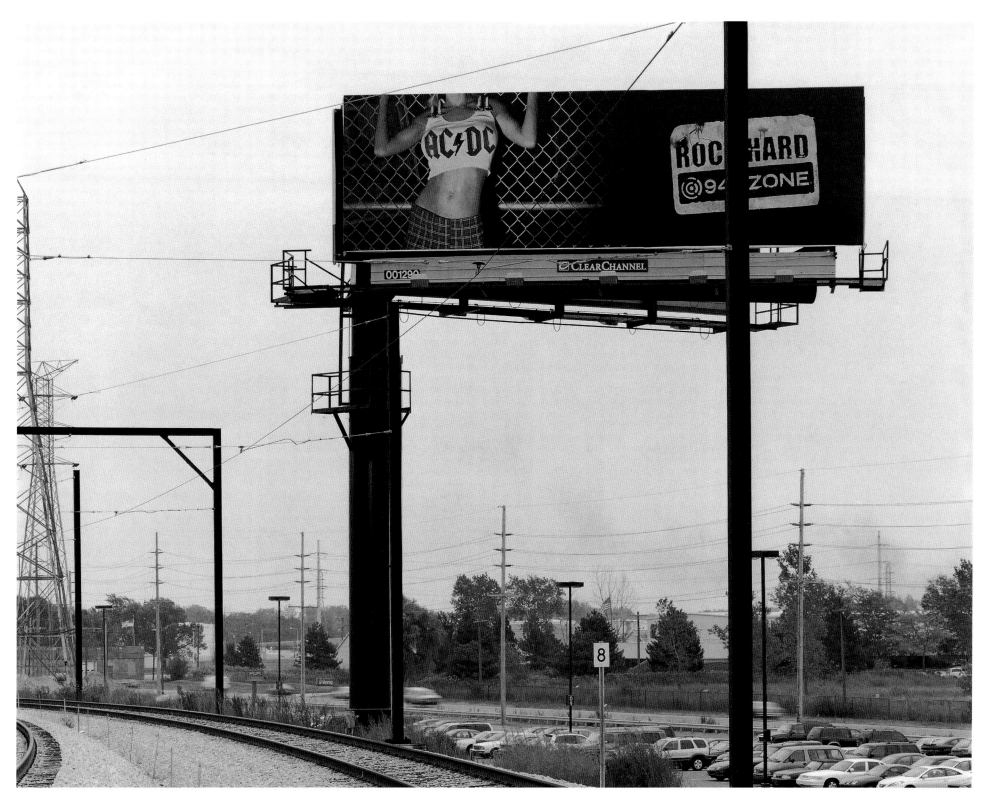

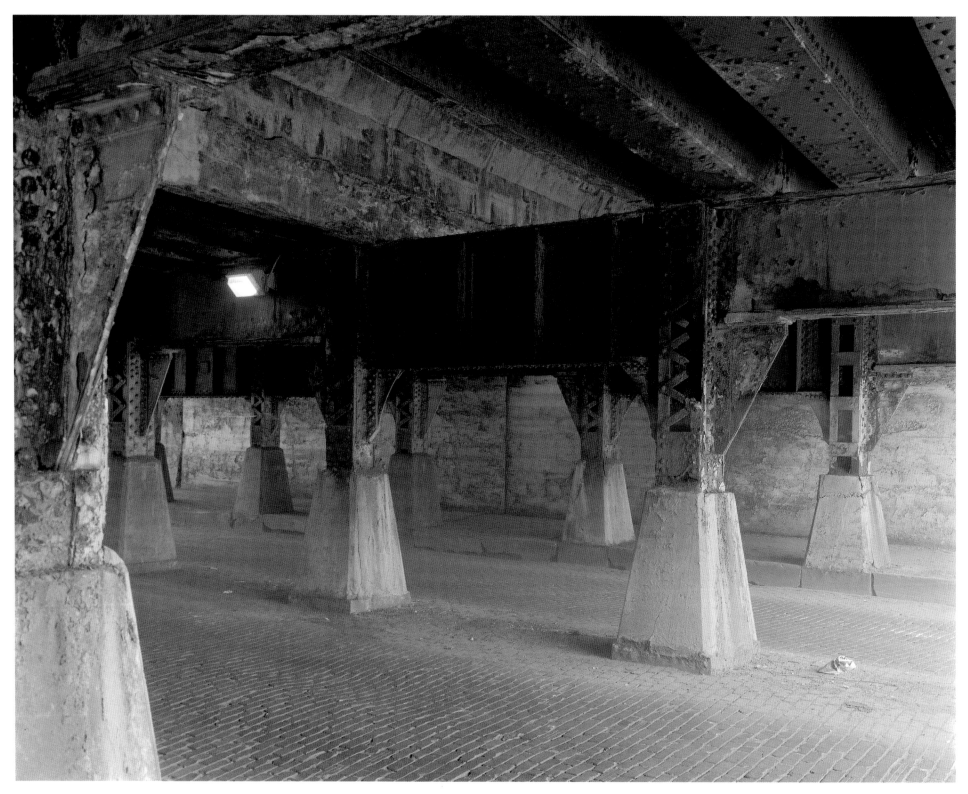

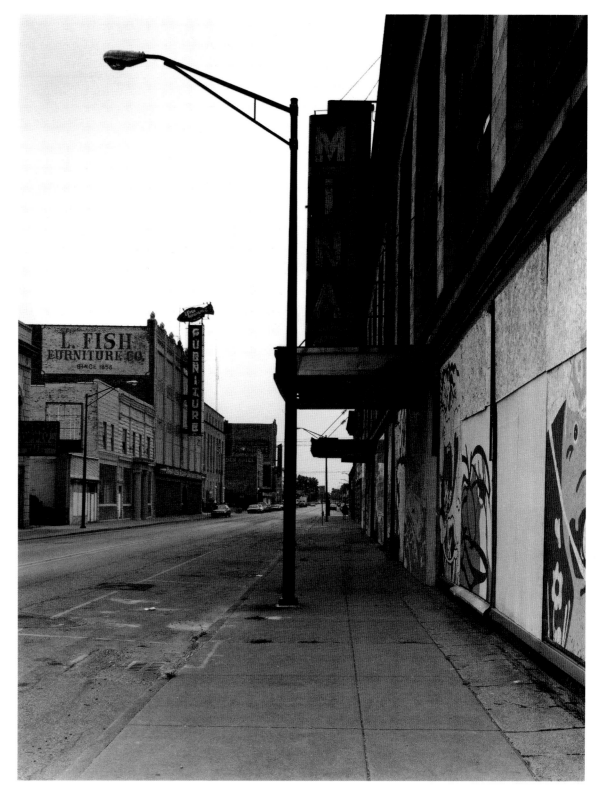

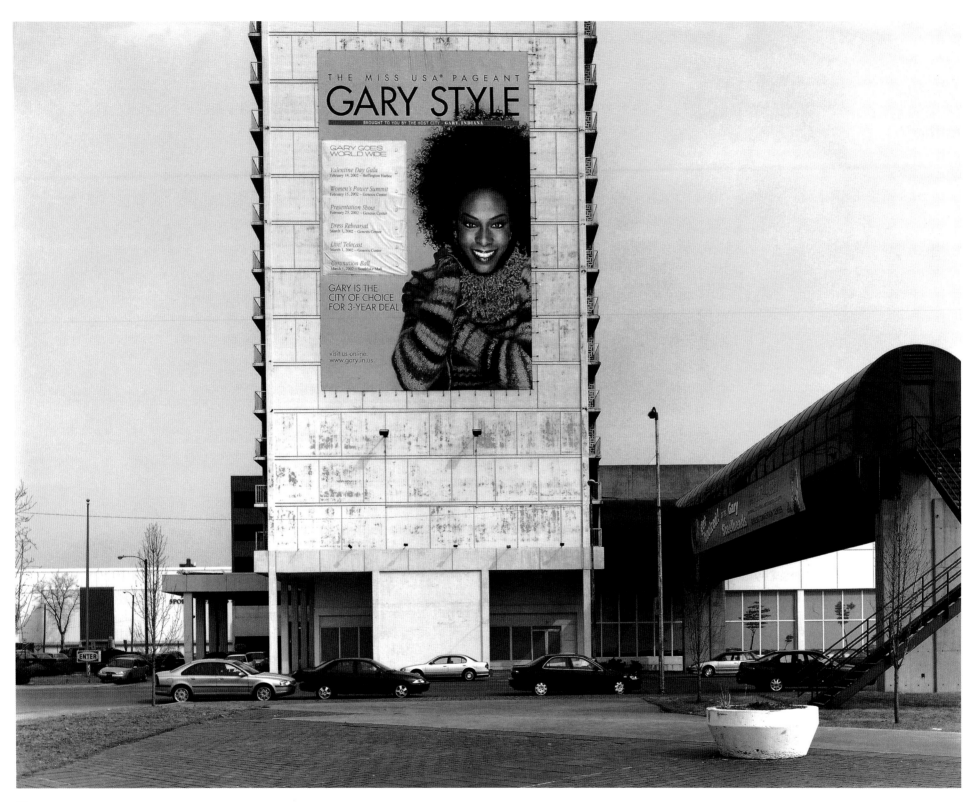

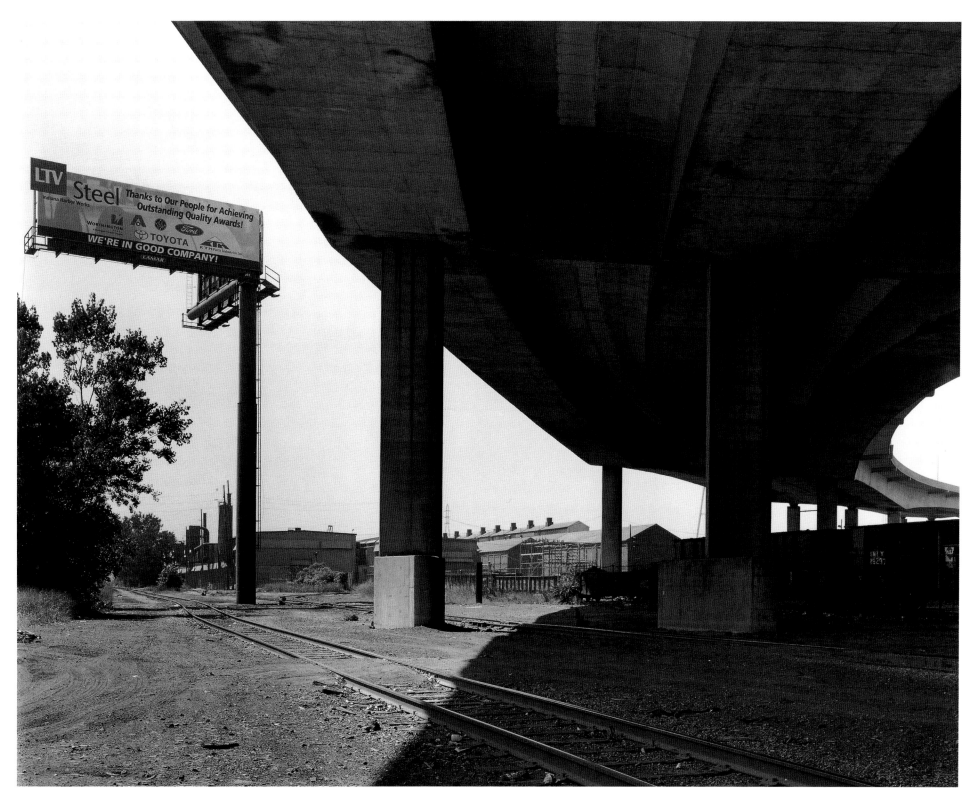

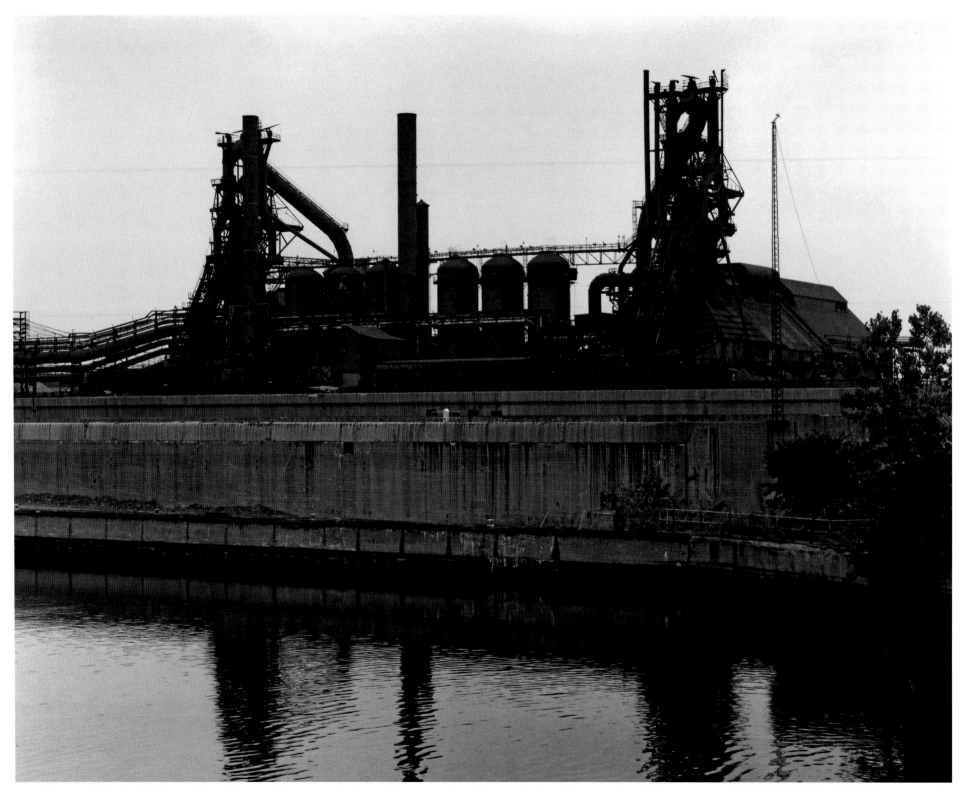

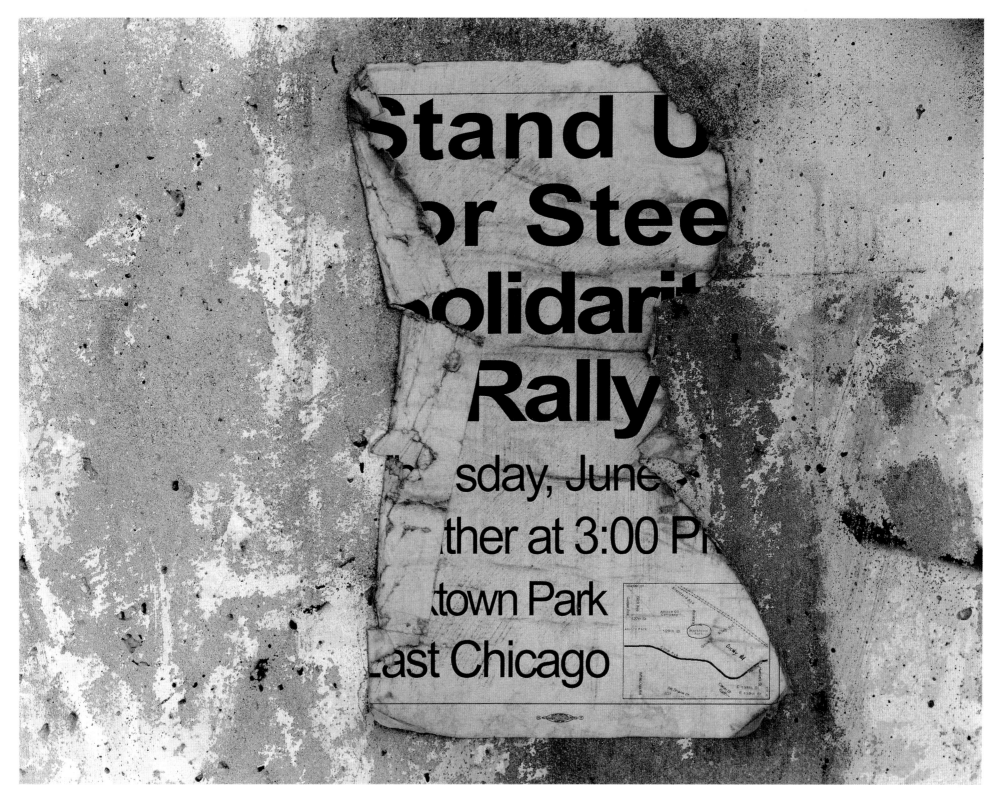

The border of Indiana and

On the south shore of Lake

All roads lead elsewhere.

Illinois.
Michigan.

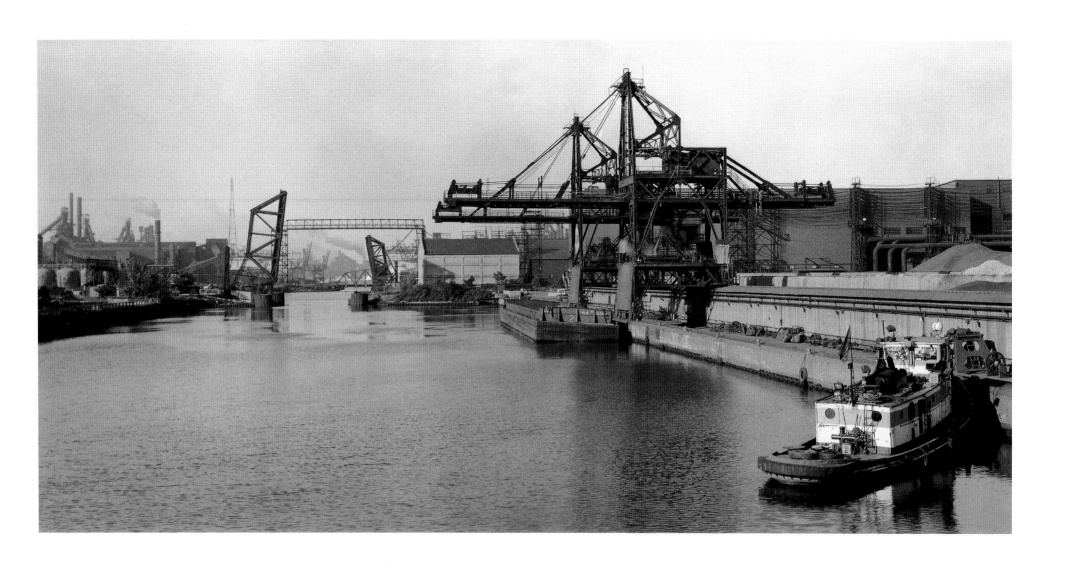

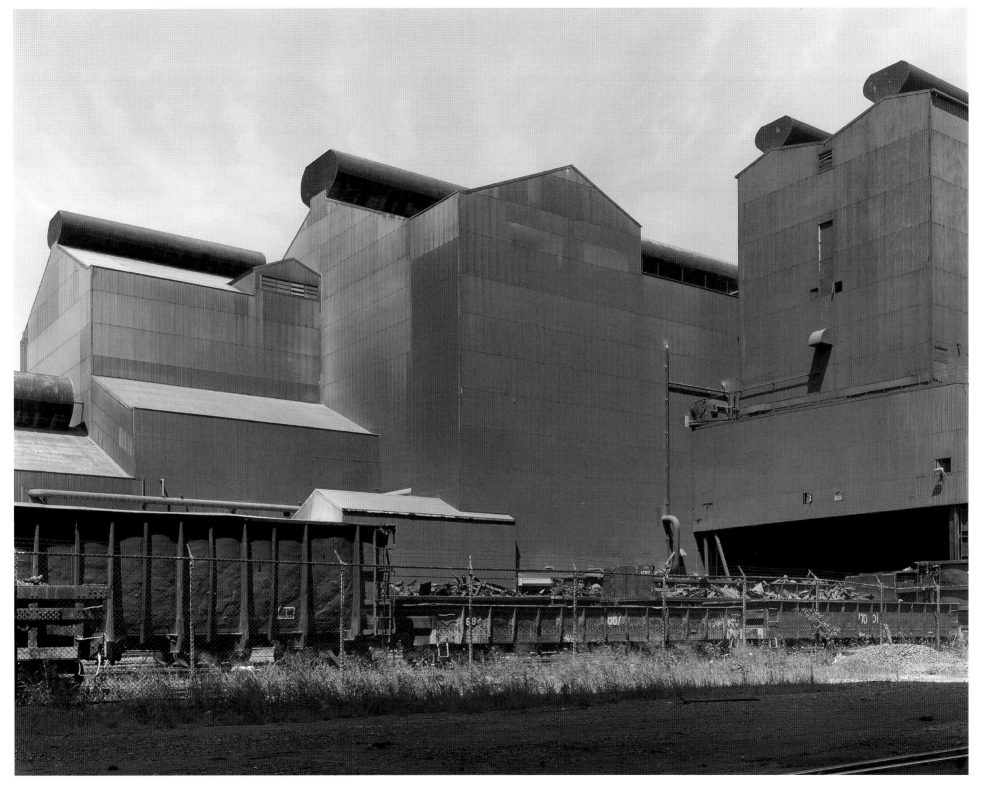

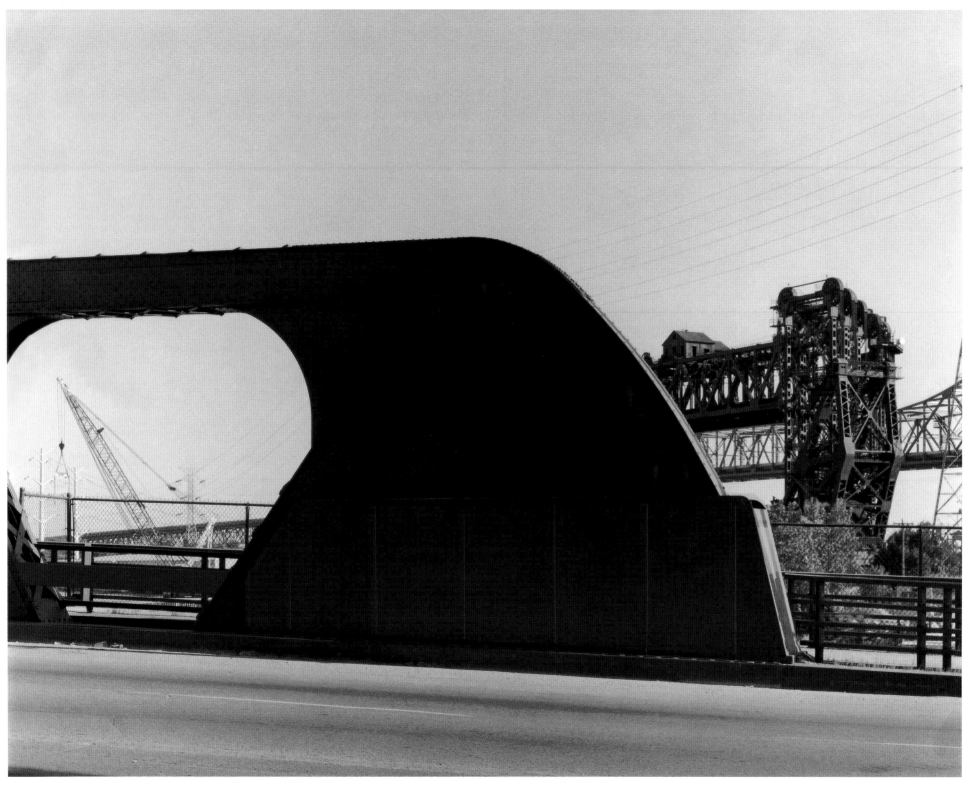

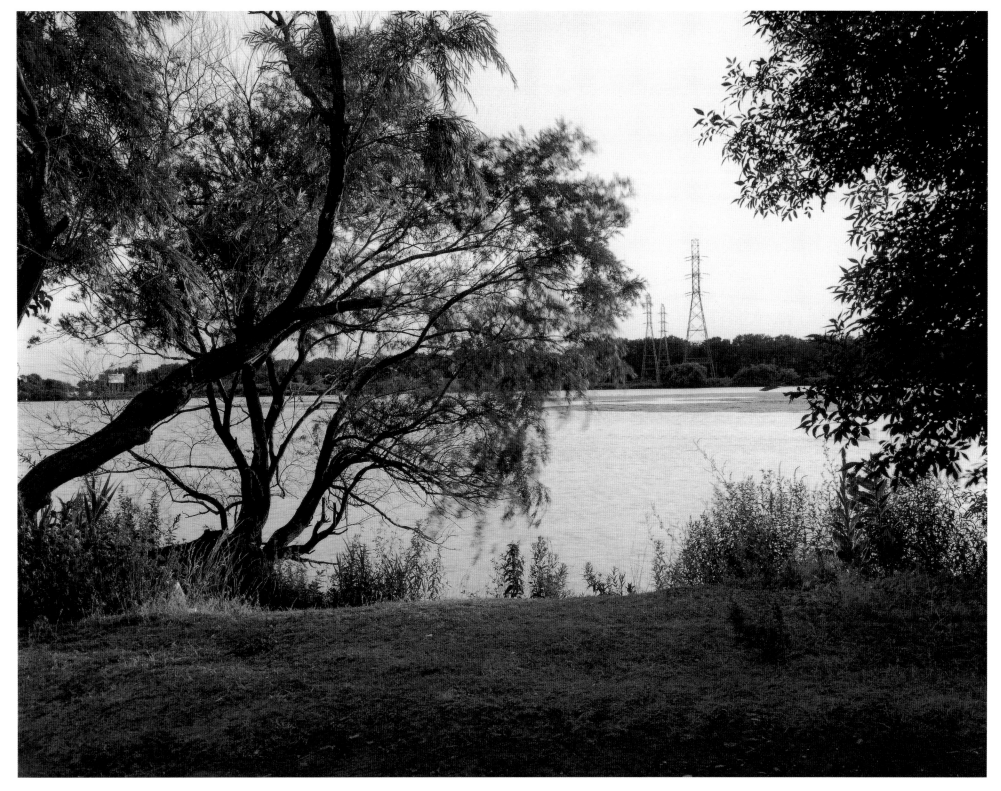

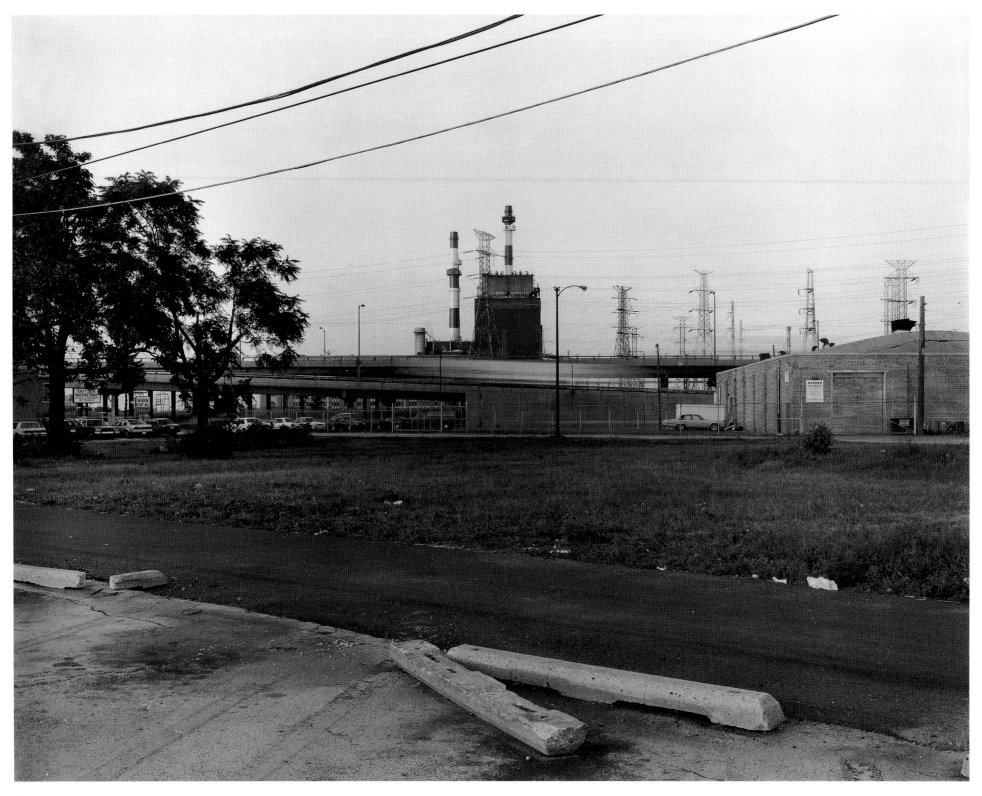

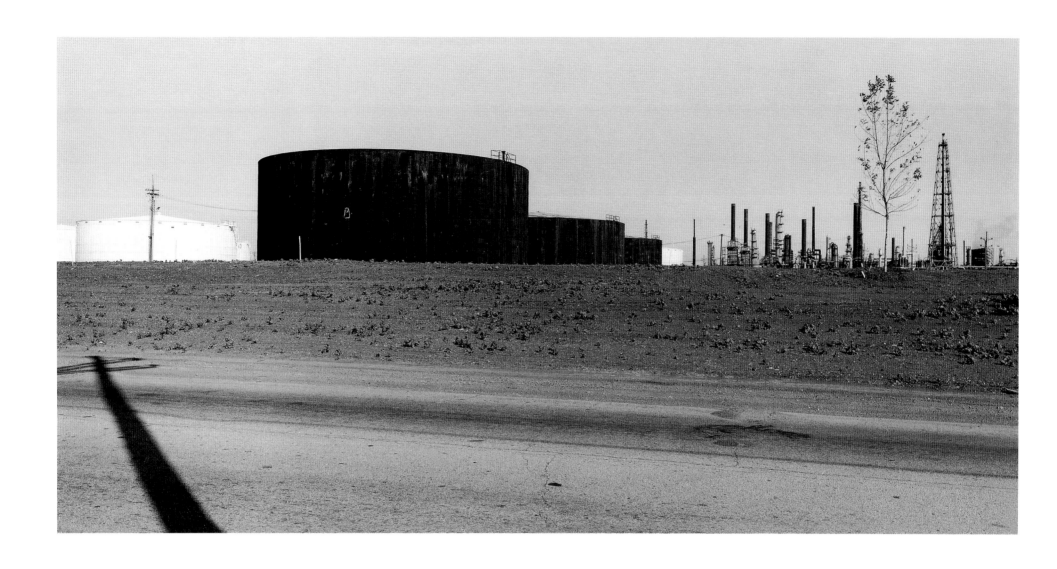

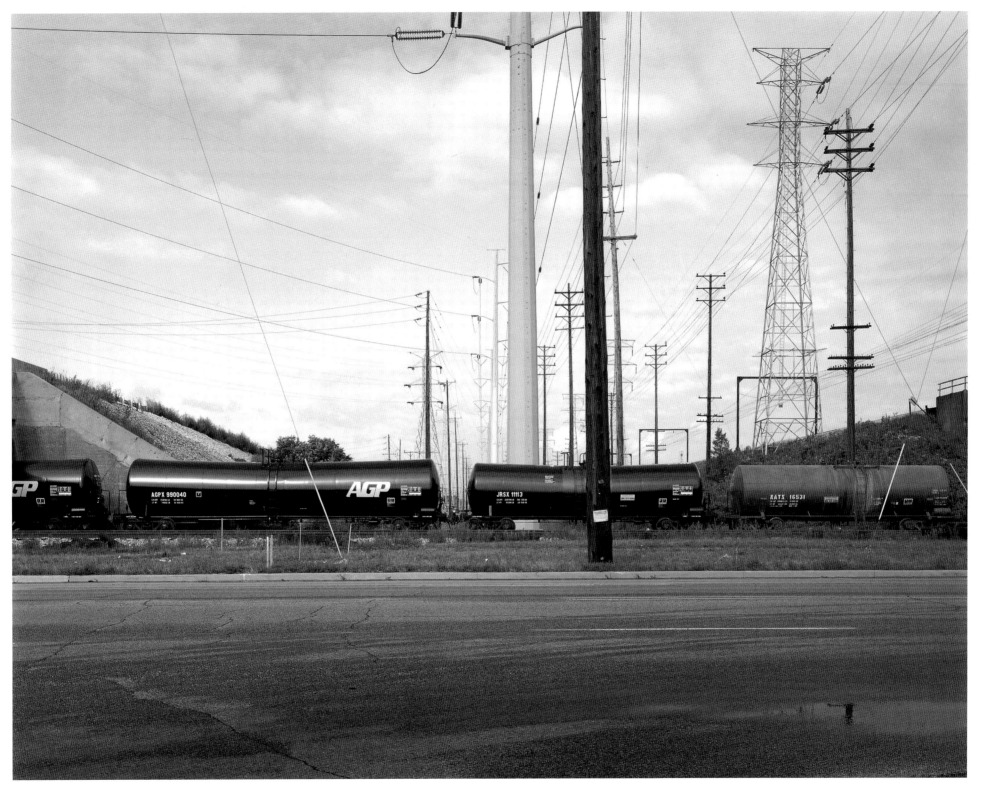

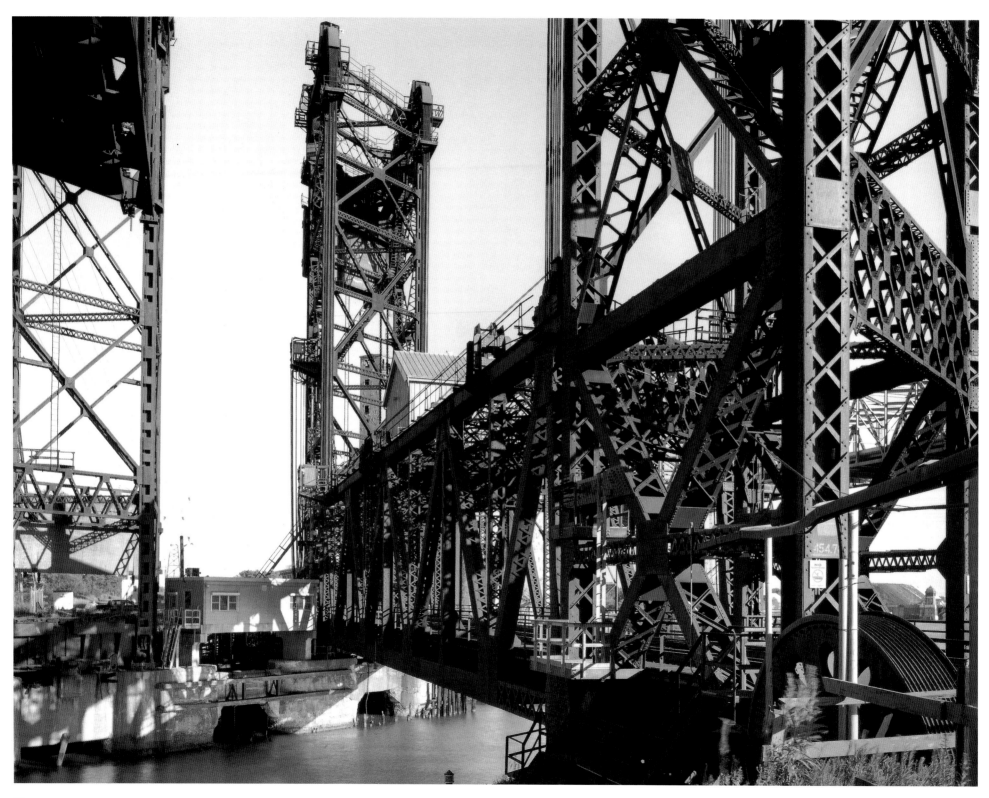

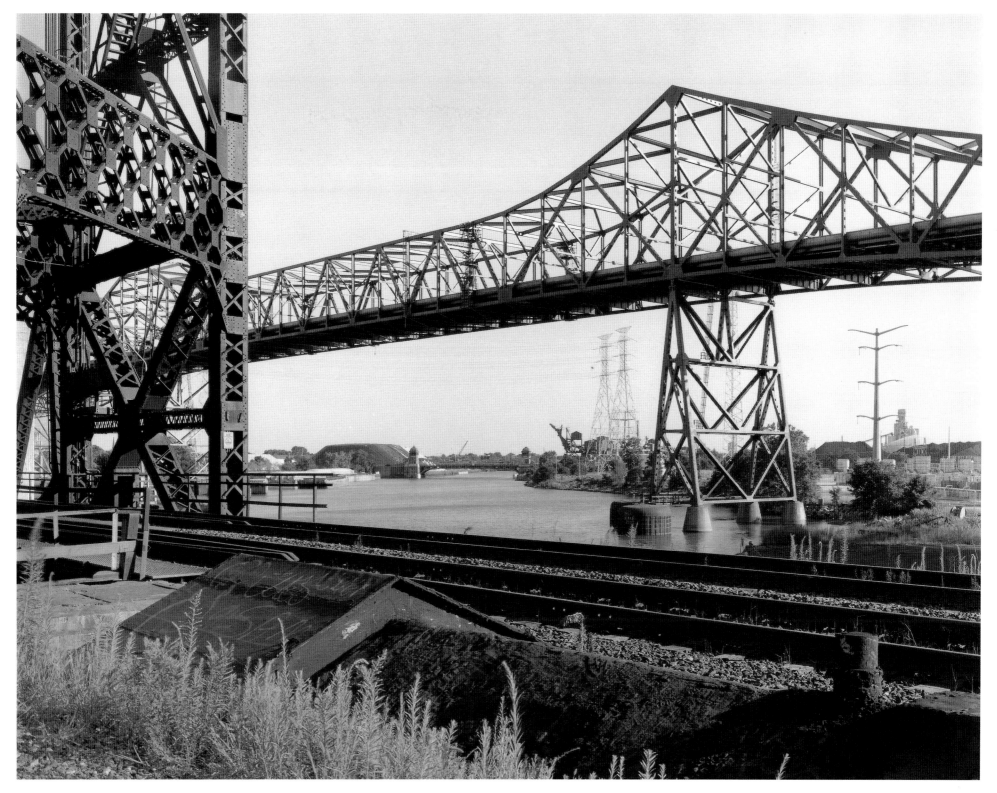

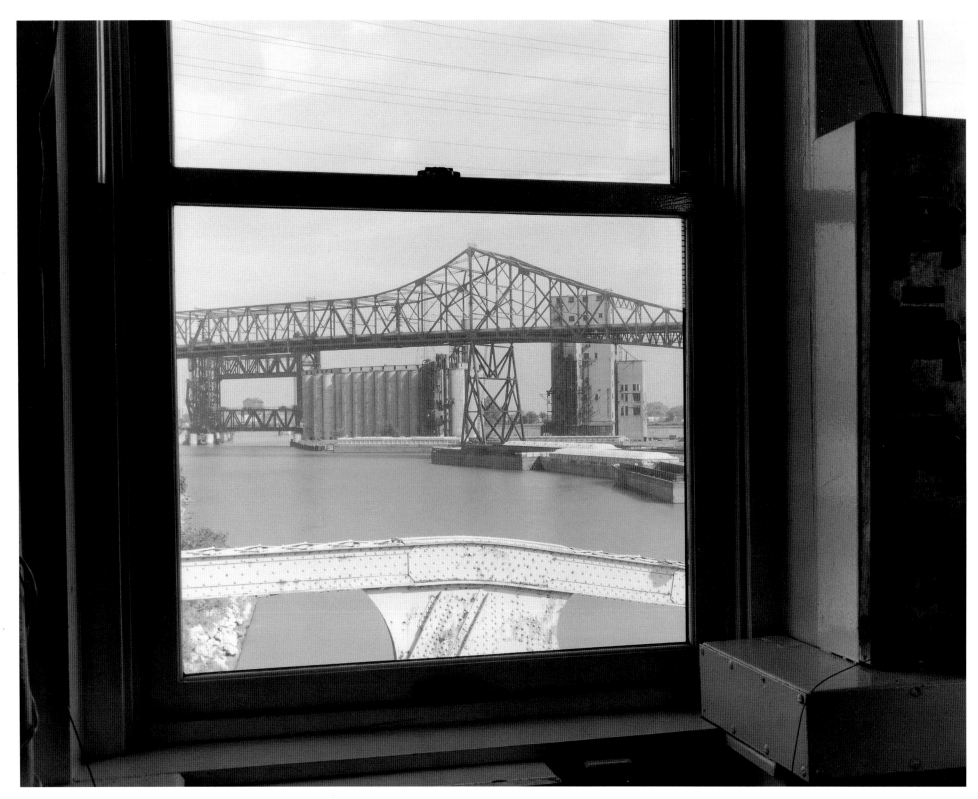

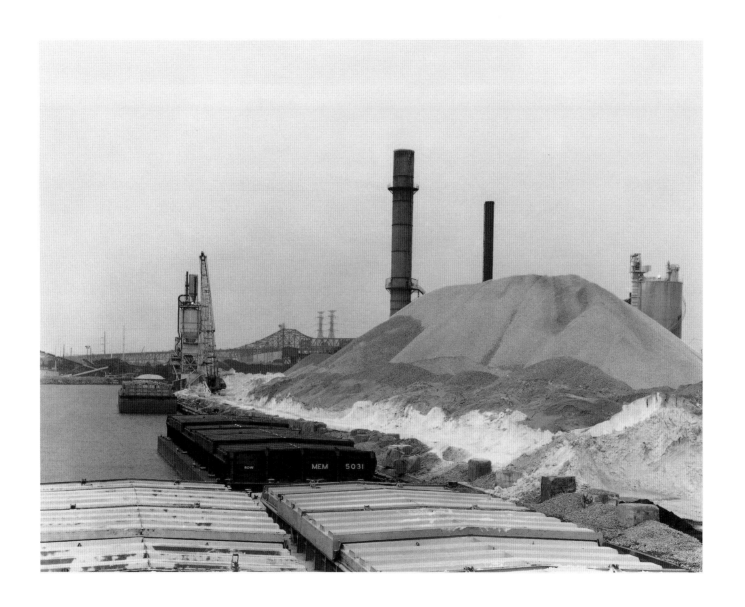

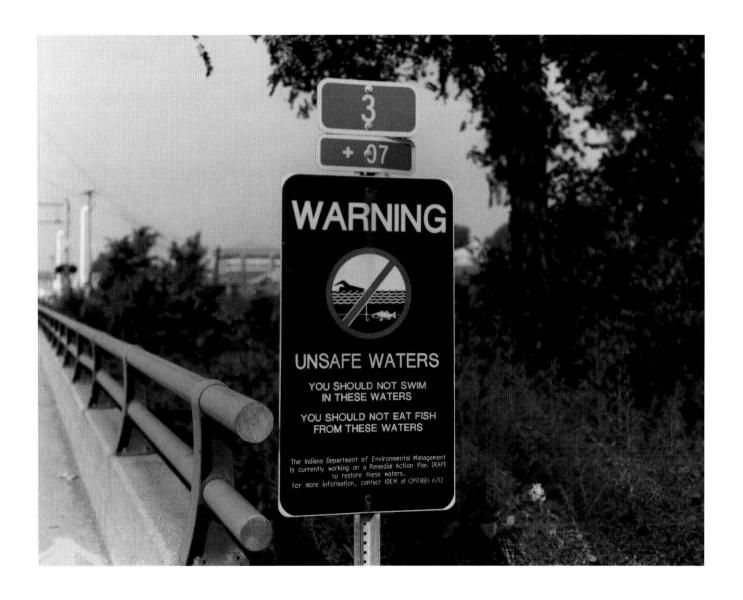

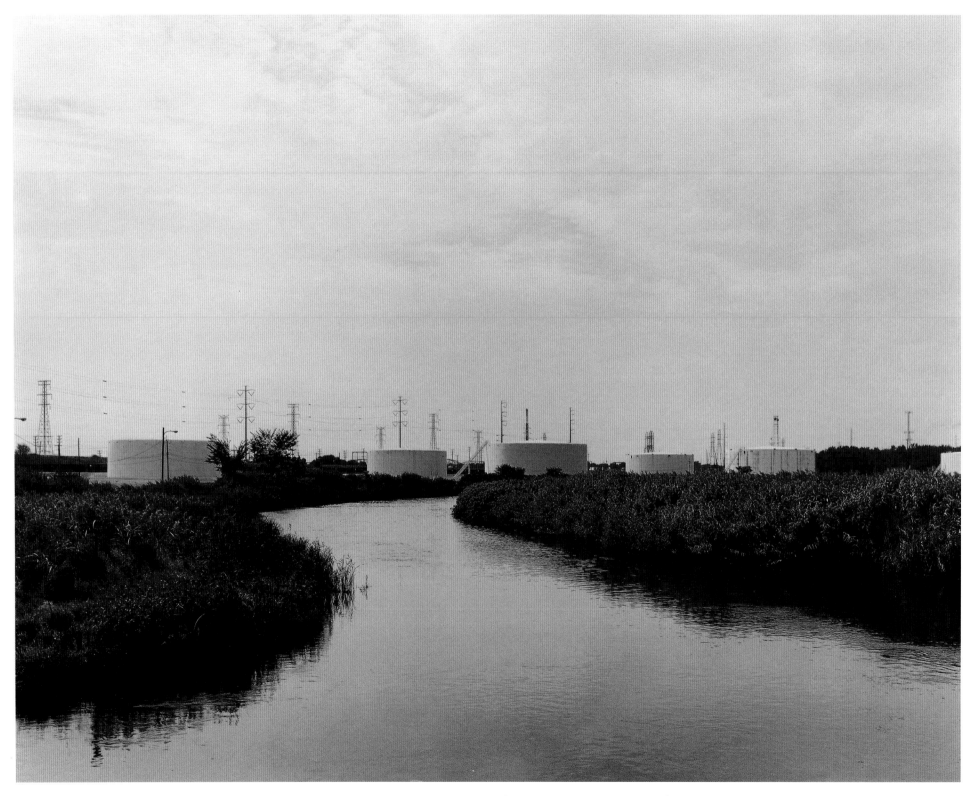

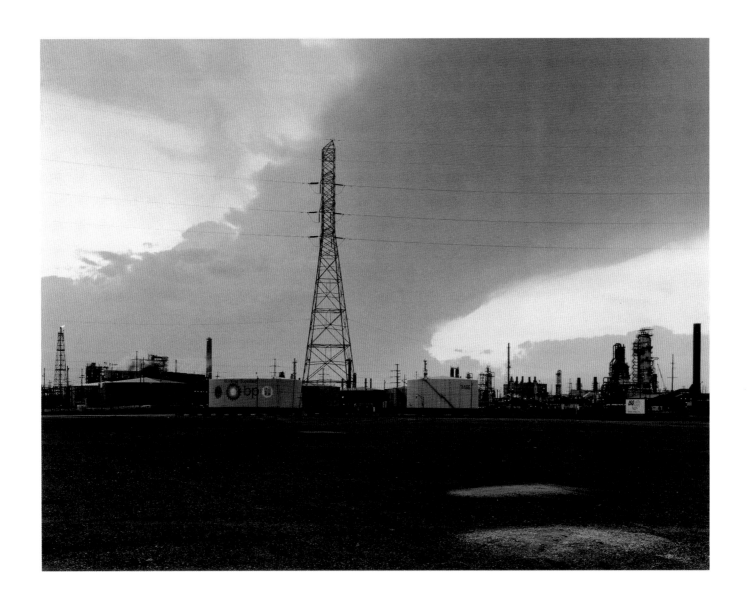

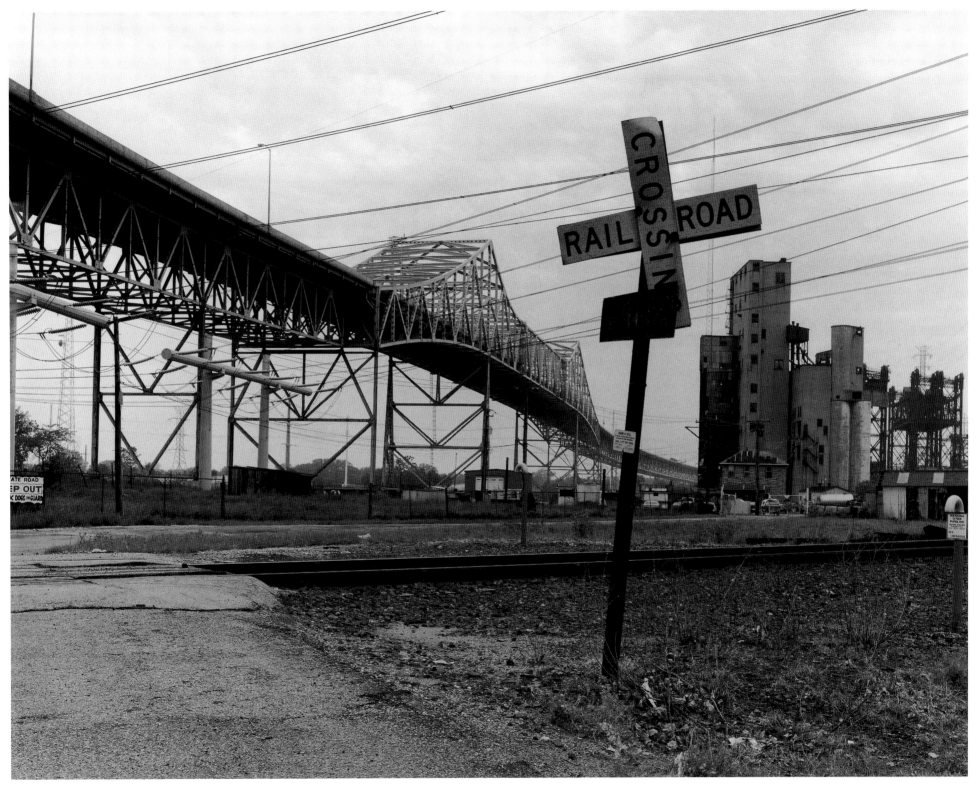

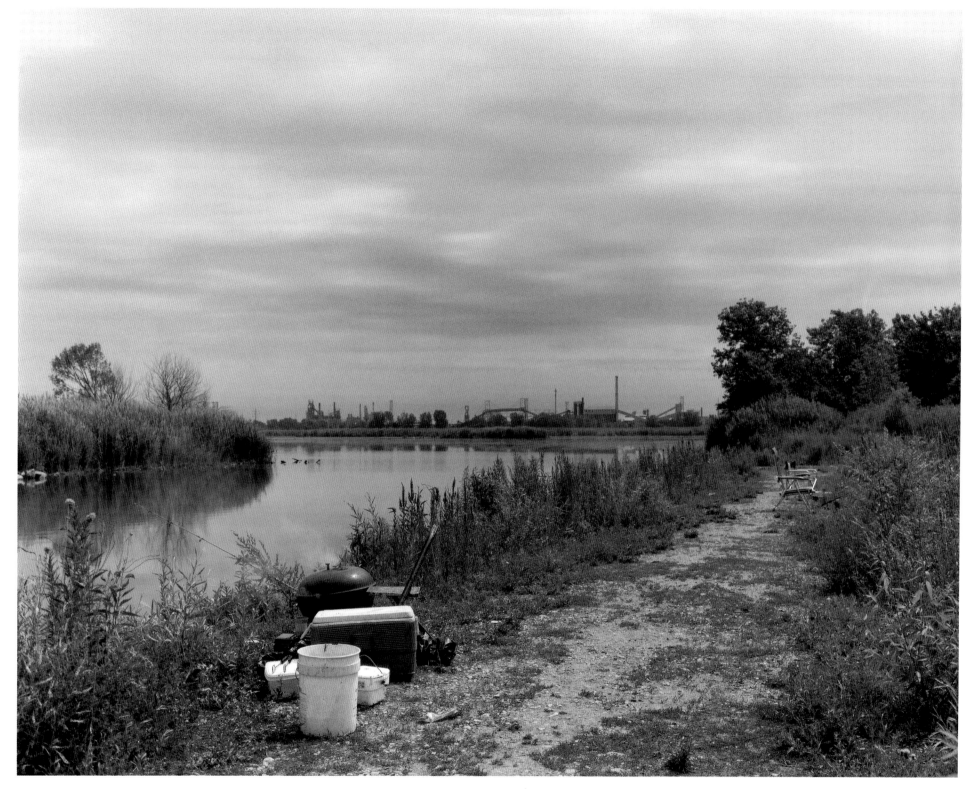

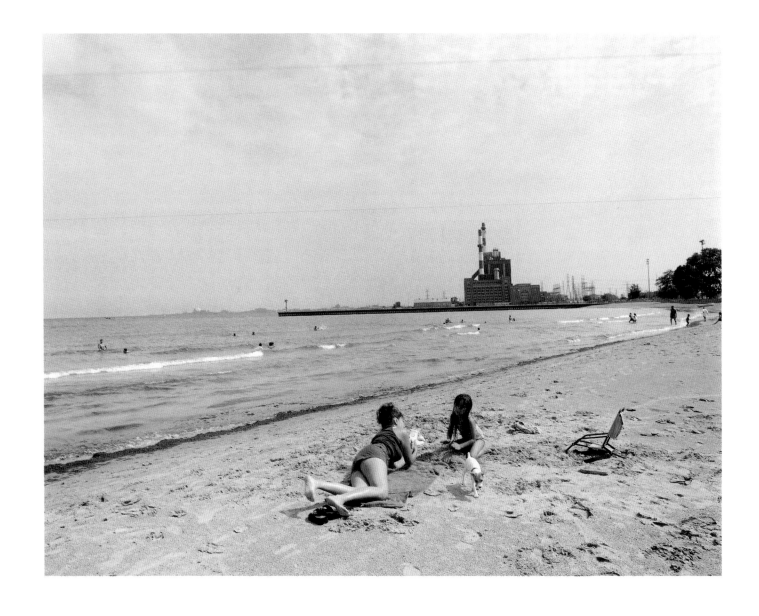

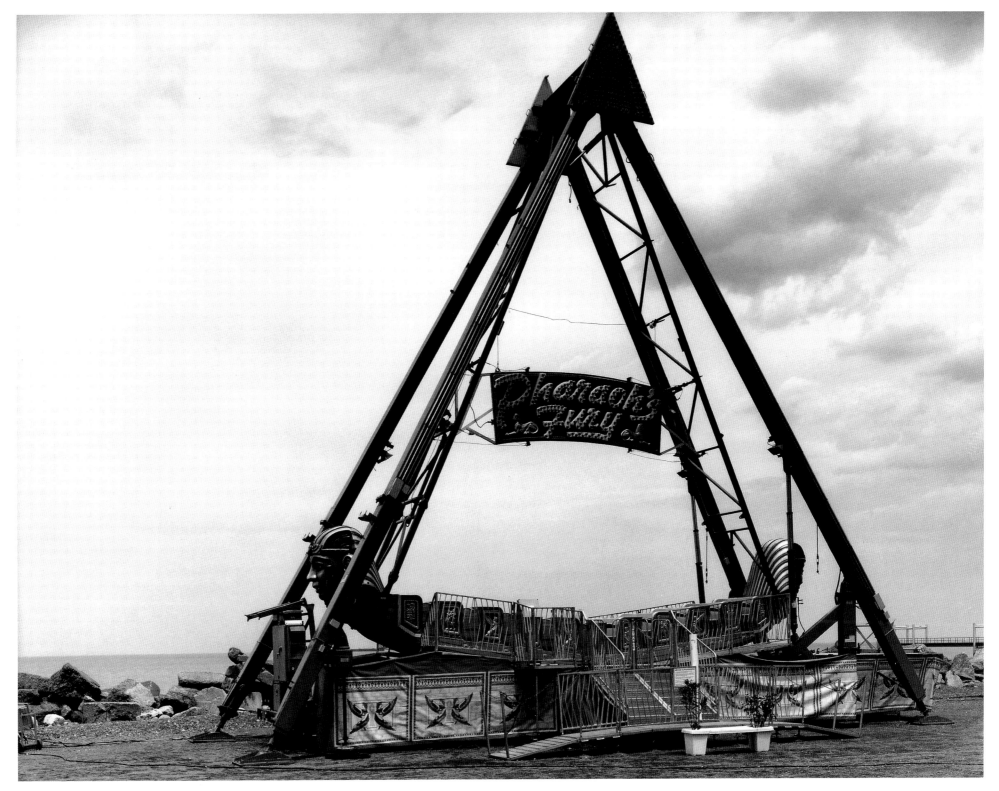

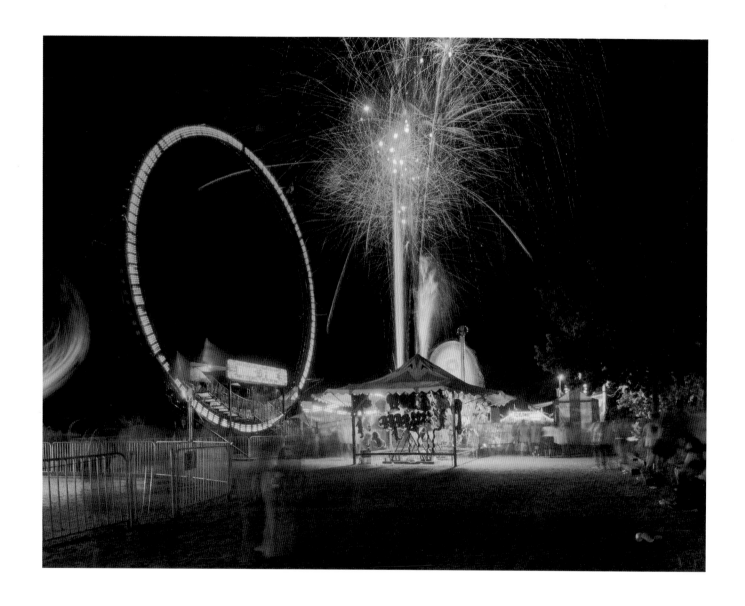

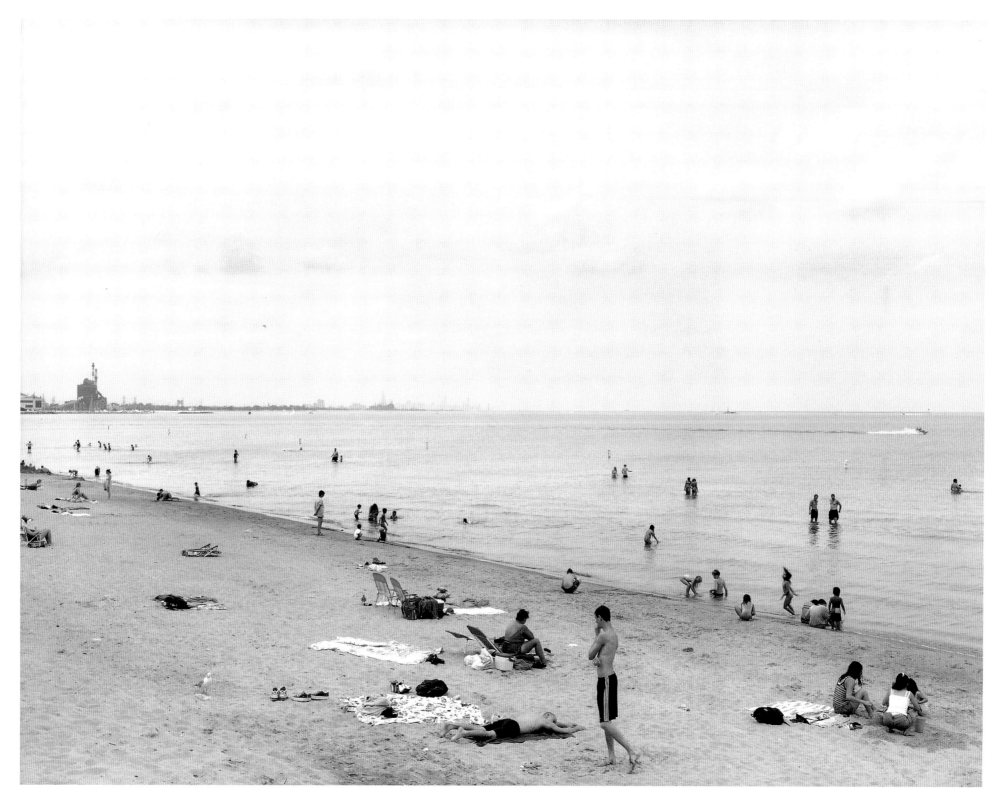

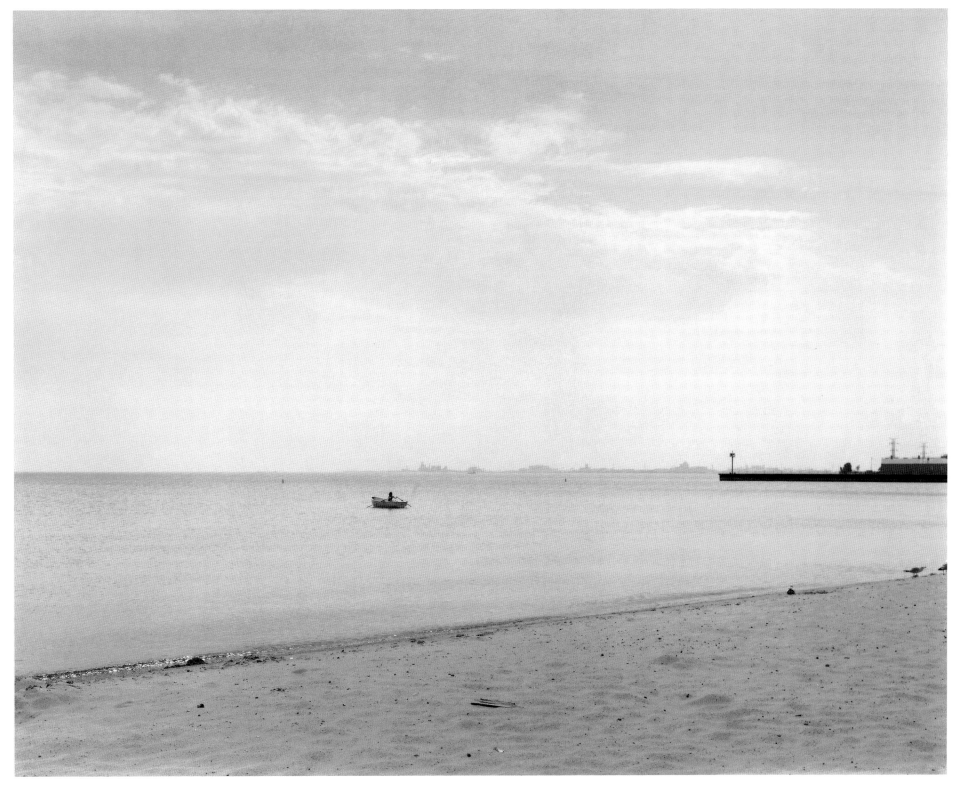

Captions

By page number

Acknowledgments

The Brauer Museum of Art at Valparaiso University is pleased to present the work of a photographer whose beautiful images capture well the face of the Calumet Region. This book reflects the Brauer's commitment to demonstrating through its exhibitions and publications its awareness of artistic and historical developments in the region it calls its home.

This book would not have been possible without the generous assistance of a number of individuals, institutions, and resources. We at the museum extend our thanks to the following persons and agencies from Valparaiso University: Roy Austensen, Richard H. W. Brauer, the Brauer Museum of Art's Brauer Endowment, the Brauer Museum of Art's Robert and Caroline Collings Endowment, Joan Catapano and the staff of the University of Illinois Press, Alan Harre, Renu Juneja, Jane Lyle, Partners for the Brauer Museum of Art, Gloria Ruff, John Ruff, LaDonna Trapp, and Katharine Wehling.

We also wish to thank Susan Carr, Gary and Joyce Cialdella, Patrick Goley and the staff of Professional Graphics Inc., Maria Grillo and Katherine Walker of The Grillo Group Inc., Adam Heet, Danielle Ren Hertzlieb, and Charles G. Kratz, Jr.

Photographer's Acknowledgments

I want to thank, first and foremost, the Brauer Museum of Art, and especially Gregg Hertzlieb, who has championed this project from the beginning; and also the publisher, the University of Illinois Press. Thanks to my darkroom assistant, Sarah Scott; to Maria Grillo and Katherine Walker for the excellent design they produced; and to David Isaacson for his assistance, encouragement, and friendship.

Additionally, my gratitude goes out to Frank Gohlke for the force of his ideas and his articulate photographs; to Dick Stevens, Professor Emeritus at the University of Notre Dame, respected teacher and artist; to my colleague and friend Susan Carr for the acute judgment I have come to trust; and to Larry Fink for his galvanizing photographs and friendship.

Contributors

Gary Cialdella

Gary Cialdella was born in Chicago and raised in nearby Blue Island, Illinois. He earned his MFA in photography from the University of Notre Dame and holds an MA in history from Western Michigan University. Cialdella is a photographer working in the social landscape tradition, a professional architectural photographer, and an educator. He chaired the photography program at the Kalamazoo Institute of Arts from 1977 to 1984 and has taught photography and photographic history at various universities, including Western Michigan University and the University of Notre Dame. He most recently taught the course "Topics in Photography: A Sense of Place" at Kendall College of Art and Design in Grand Rapids, Michigan.

Cialdella's first series, *The Shoreline Project: 1982–83*, was awarded a grant from the Michigan Council for the Humanities. This photographic survey examined the changing social landscape of the shoreline of Lake Michigan. An additional series, *Landscapes of Southwest Michigan: 1984–85*, was supported by a grant from the Michigan Council for the Arts. Cialdella's Midwest landscapes were selected for inclusion in the Art Institute of Chicago's exhibition "An Open Land: Photographs from the Midwest, 1852–1982," and were subsequently published as an Aperture Monograph.

In 1986 Cialdella began the *Calumet Series*, documenting his home region, the industrial area of South Chicago, Illinois, and Northwest Indiana. Other series he has completed include *Delta Blues: The Casino Landscape of North Mississippi: 1997–2003*; *American Habitat: Photographs from Post Industrial America*; and *Picturing Pilsen: A Chicago Latino Neighborhood*. His work has been represented in the Museum of Contemporary Photography's Midwest Photographers Archive and is included in many corporate and private collections, such as the LaSalle Bank Photography Collection, the Pfizer Corporation Collection, the Kalamazoo Institute of Arts, and the Brauer Museum of Art.

Gregg Hertzlieb

Gregg Hertzlieb is Director/Curator of the Brauer Museum of Art at Valparaiso University in Valparaiso, Indiana. Hertzlieb has an MFA from the School of the Art Institute of Chicago and an MEd from the University of Illinois at Chicago. He is editor of the book *Domestic Vision: Twenty-Five Years of the Art of Joel Sheesley* (2008), as well as a contributor to *The Indiana Dunes Revealed: The Art of Frank V. Dudley* (2006). In addition to performing his duties at the museum, Hertzlieb teaches Museum Studies, serves as art editor for Valparaiso University's journal *The Cresset*, and contributes essays on Brauer collection objects to the *Valparaiso Poetry Review*. Hertzlieb is a native of Northwest Indiana and lives in Chesterton.

John Ruff

John Ruff is Associate Professor of English and Director of the Valpo Core at Valparaiso University in Valparaiso, Indiana. Ruff earned his Bachelor of Arts degree from St. John's University in Collegeville, Minnesota, was awarded an MAT from the College of St. Thomas in St. Paul, Minnesota, and received his MA in English with a concentration in Creative Writing from The University of Washington in Seattle, where he also completed a Ph.D. in English literature. Ruff taught at the elementary, middle, and high school levels in Minnesota, Oregon, and Rome, Italy, before moving to Valparaiso, Indiana, in 1989 to teach at Valparaiso University. He has taught a broad variety of courses at Valparaiso, including a course on landscape and American literature. In 2000 he curated an exhibit at the Brauer Museum of Art on Junius Sloan's Kaaterskill Lakes and the Catskill Mountain House. Ruff serves as the poetry editor for Valparaiso University's journal *The Cresset*. His own poems have appeared in a variety of literary journals, most recently in *Post Road* and *Christianity and Literature*. Ruff was born in Minnesota and is married to the photographer Gloria Ruff.

SUBTRACTION

By CHARLES GHIGNA

Illustrations by MISA SABURI

Music by ERIK KOSKINEN

CANTATA
LEARNING

WWW.CANTATALEARNING.COM

CANTATA
LEARNING

Published by Cantata Learning
1710 Roe Crest Drive
North Mankato, MN 56003
www.cantatalearning.com

Library of Congress Cataloging-in-Publication Data
Names: Ghigna, Charles. | Saburi, Misa, illustrator. | Koskinen, Erik.
Title: Subtraction / by Charles Ghigna ; illustrations by Misa Saburi ; music
 by Erik Koskinen.
Description: North Mankato, MN : Cantata Learning, [2018] | Series: Winter
 math | Audience: Age 3-8. | Audience: K to grade 3.
Identifiers: LCCN 2017007528 (print) | LCCN 2017016718 (ebook) | ISBN
 9781684100545 | ISBN 9781684100538 (hardcover : alk. paper)
Subjects: LCSH: Subtraction--Juvenile literature. | Arithmetic--Juvenile
 literature.
Classification: LCC QA115 (ebook) | LCC QA115 .G44 2018 (print) | DDC
 513.2/12--dc23
LC record available at https://lccn.loc.gov/2017007528

Book design, Tim Palin Creative
Editorial direction, Flat Sole Studio
Executive musical production and direction, Elizabeth Draper
Music arranged and produced by Erik Koskinen

Printed in the United States of America in North Mankato, Minnesota.
072017 0367CGF17

ACCESS THE MUSIC!

SCAN
CODE
WITH
MOBILE
APP

CANTATALEARNING.COM

TIPS TO SUPPORT LITERACY AT HOME

WHY READING AND SINGING WITH YOUR CHILD IS SO IMPORTANT

Daily reading with your child leads to increased academic achievement. Music and songs, specifically rhyming songs, are a fun and easy way to build early literacy and language development. Music skills correlate significantly with both phonological awareness and reading development. Singing helps build vocabulary and speech development. And reading and appreciating music together is a wonderful way to strengthen your relationship.

READ AND SING EVERY DAY!

TIPS FOR USING CANTATA LEARNING BOOKS AND SONGS DURING YOUR DAILY STORY TIME

1. As you sing and read, point out the different words on the page that rhyme. Suggest other words that rhyme.

2. Memorize simple rhymes such as Itsy Bitsy Spider and sing them together. This encourages comprehension skills and early literacy skills.

3. Use the questions in the back of each book to guide your singing and storytelling.

4. Read the included sheet music with your child while you listen to the song. How do the music notes correlate to the words of the song?

5. Sing along on the go and at home. Access music by scanning the QR code on each Cantata book. You can also stream or download the music for free to your computer, smartphone, or mobile device.

Devoting time to daily reading shows that you are available for your child. Together, you are building language, literacy, and listening skills.

Have fun reading and singing!

Come enjoy the winter season with the children in this story. They see groups of 10 things. Ten snowmen stand in the snow, and 10 **hockey** players try to score. But what happens when some of those things are taken away?

Turn the page to practice subtracting numbers. Remember to sing along!

Subtracting numbers with our friends—
let's subtract from 1 to 10!

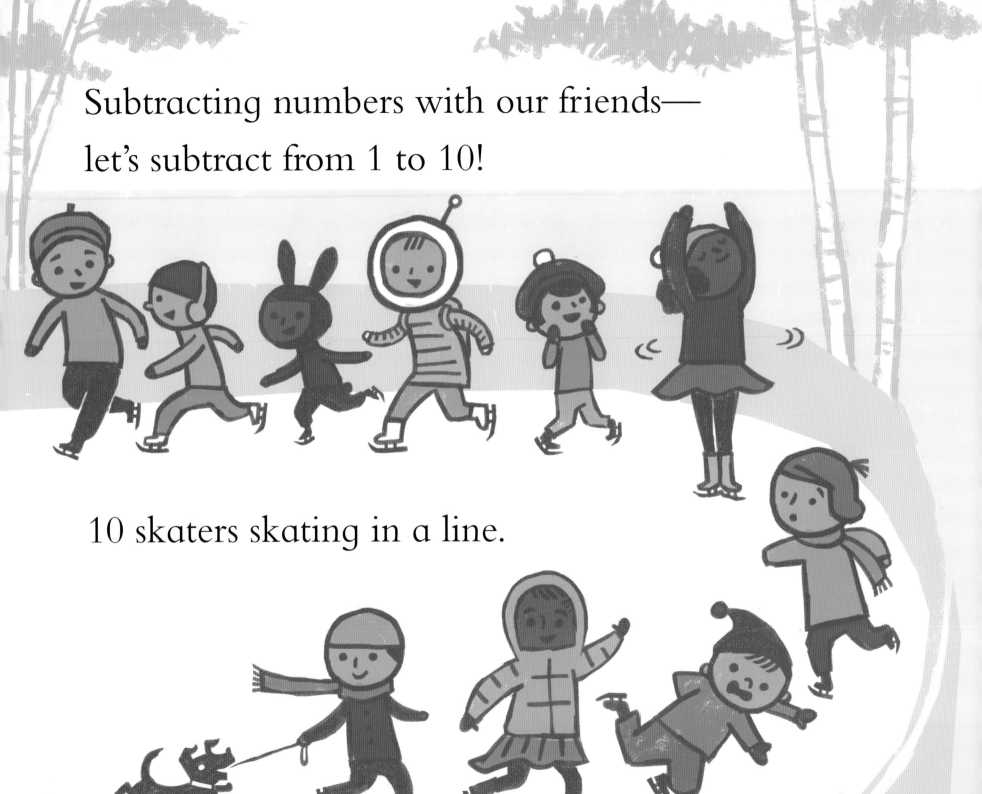

10 skaters skating in a line.

1 goes home.

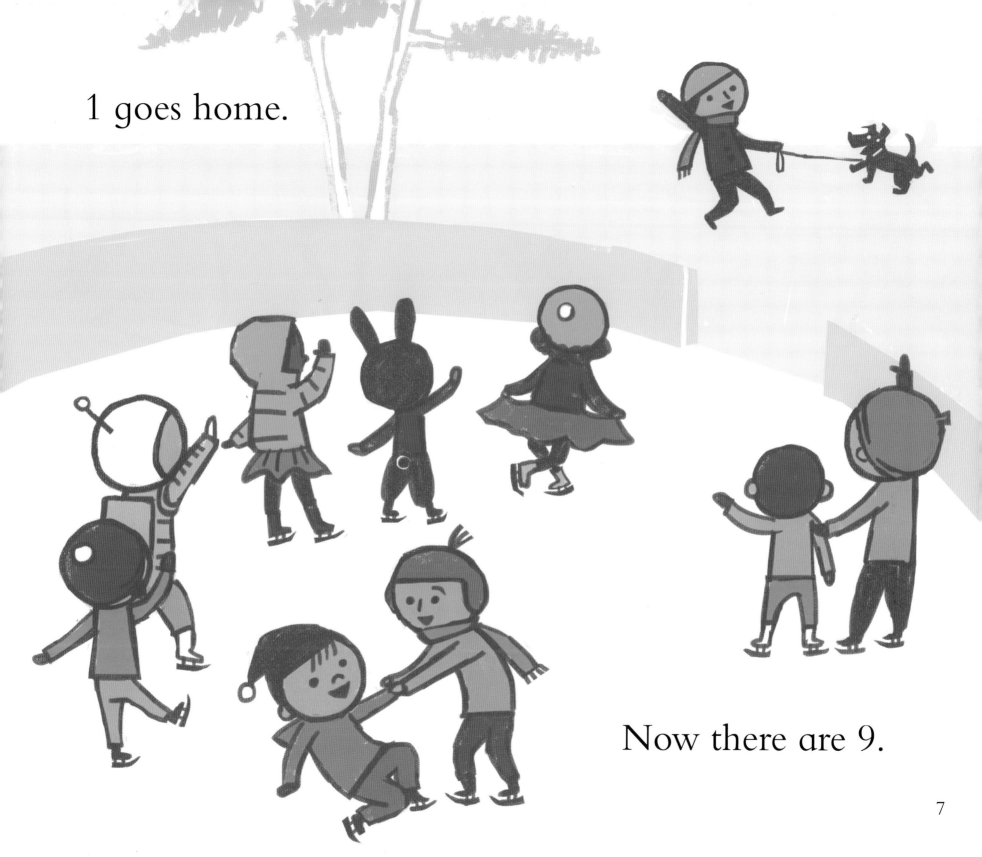

Now there are 9.

10 snow geese **soar** over a lake.

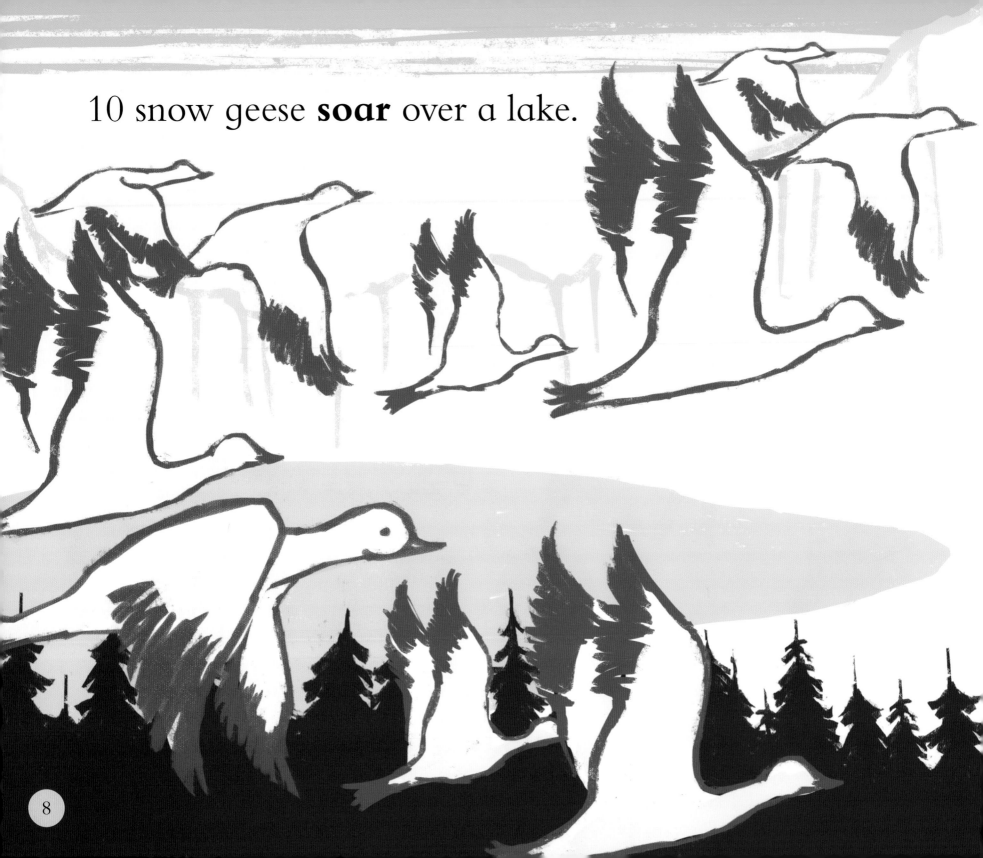

2 fly away.

Now there are 8.

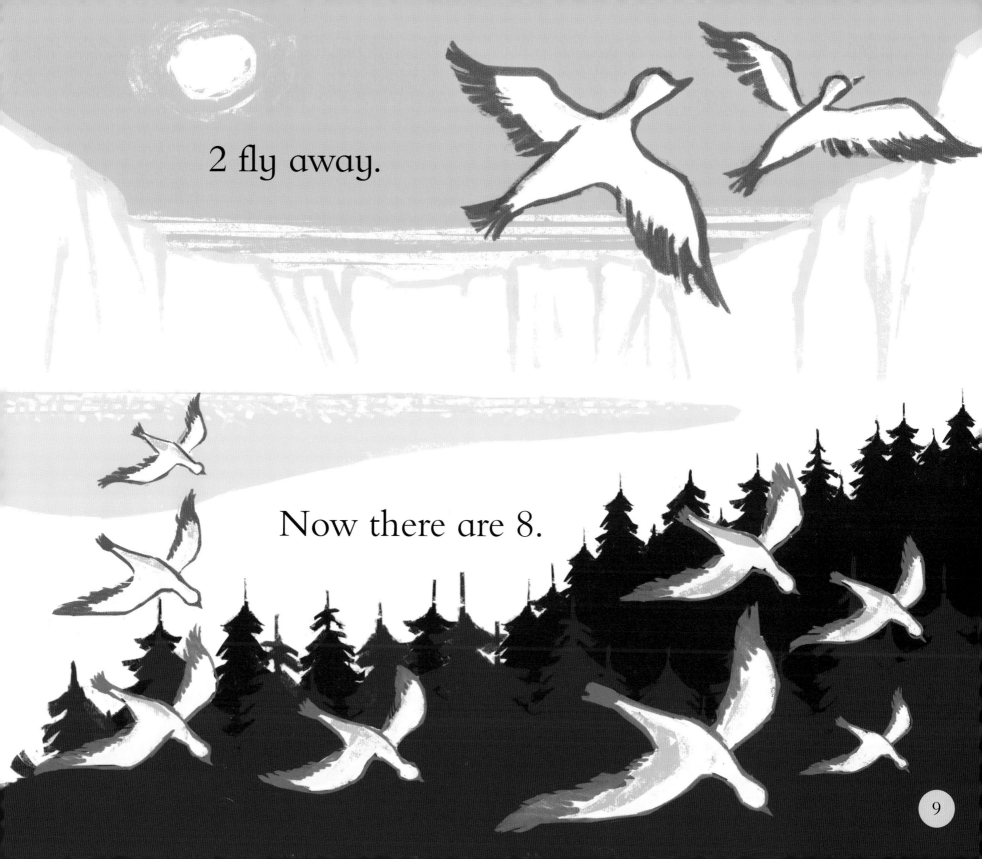

10 cookies straight from the oven.

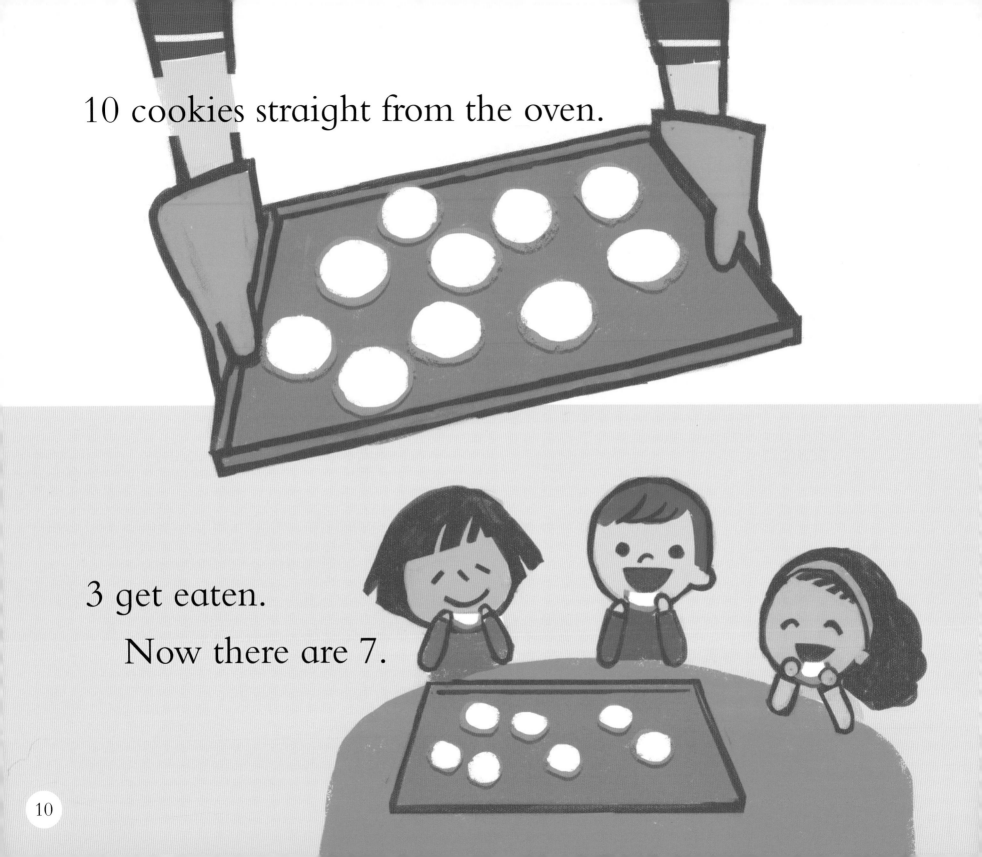

3 get eaten.
 Now there are 7.

10 candles in their candlesticks.

4 blow out.

Now there are 6.

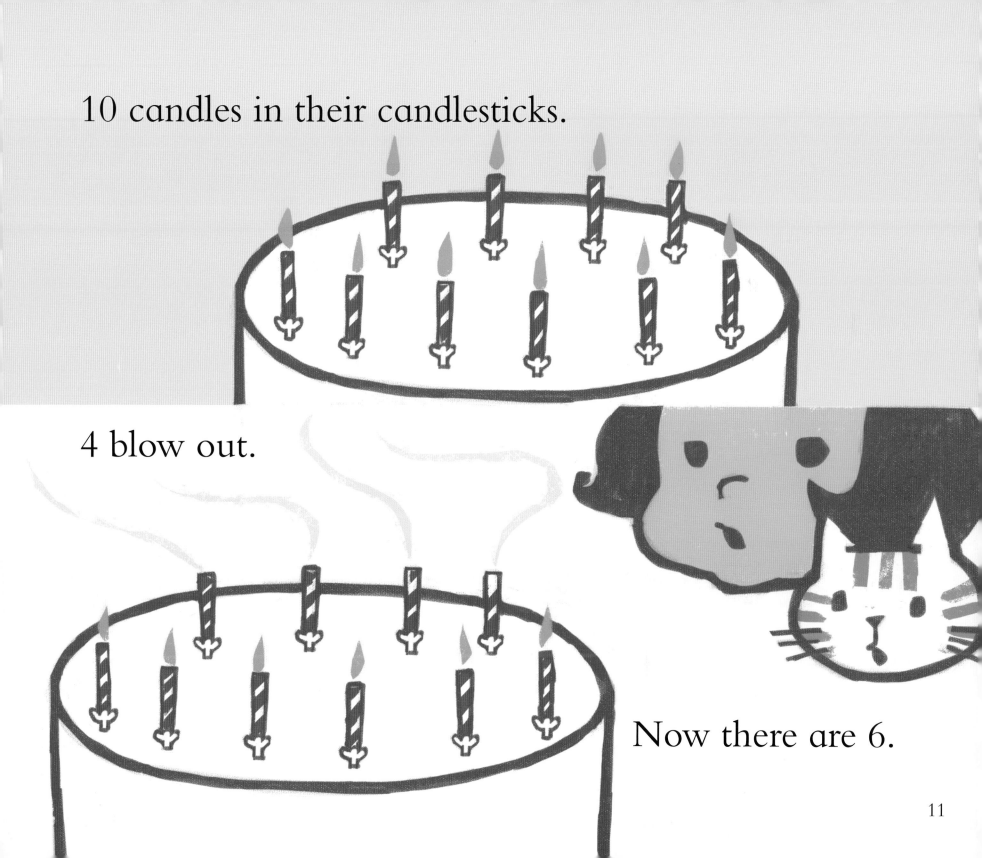

10 silly snowmen look alive.

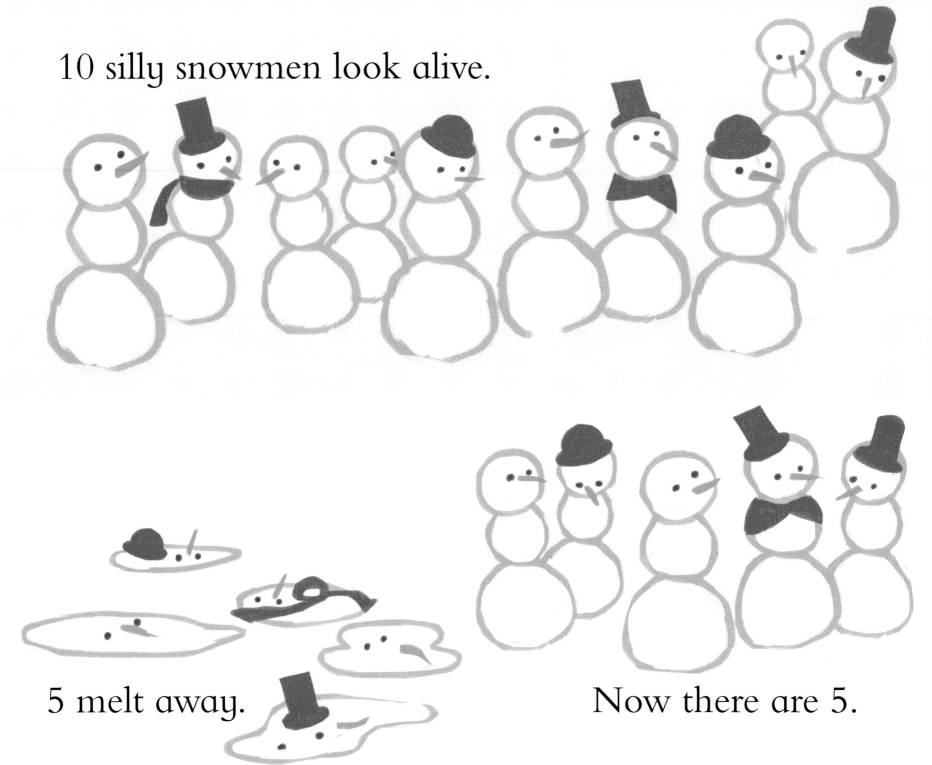

5 melt away.

Now there are 5.

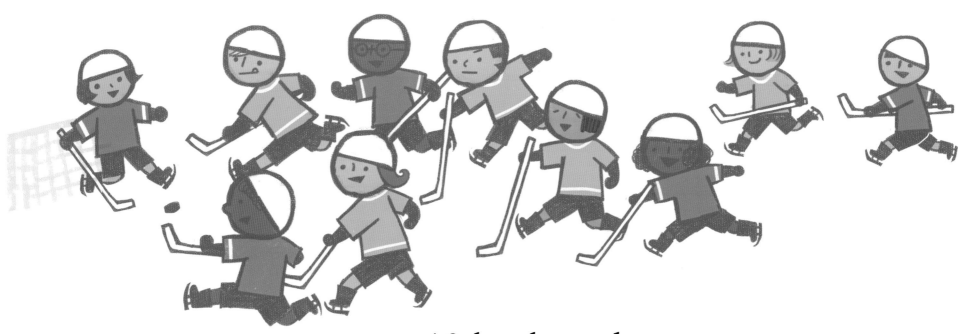

10 hockey players try to score.

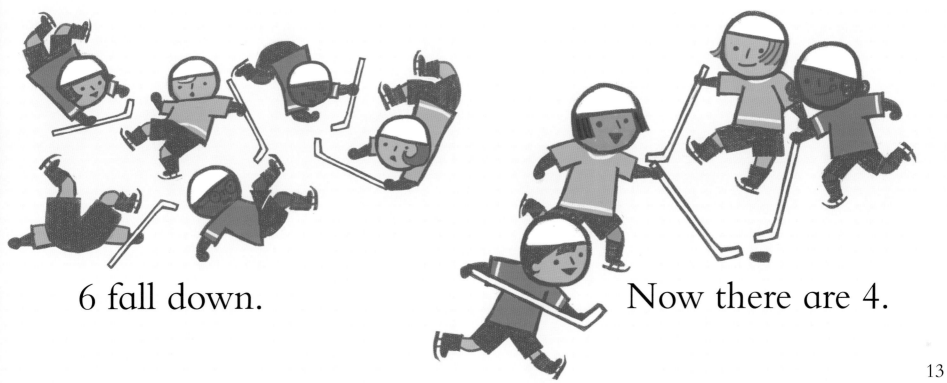

6 fall down.

Now there are 4.

10 bright cardinals up in a tree.

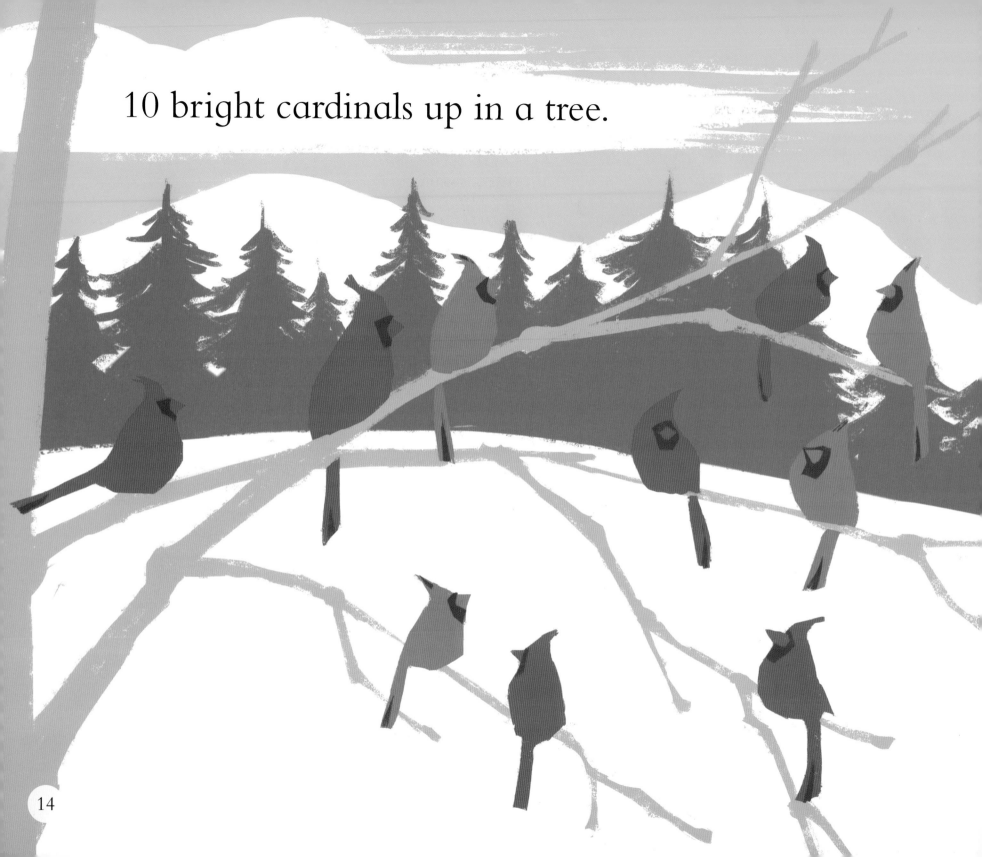

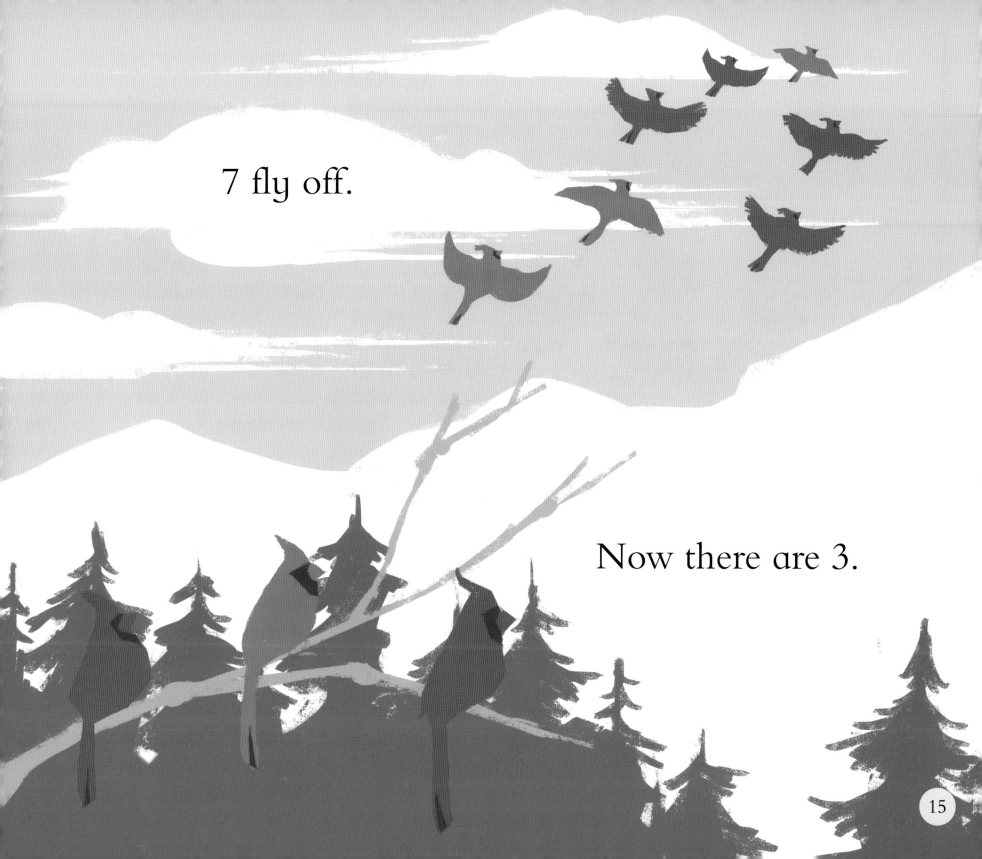

7 fly off.

Now there are 3.

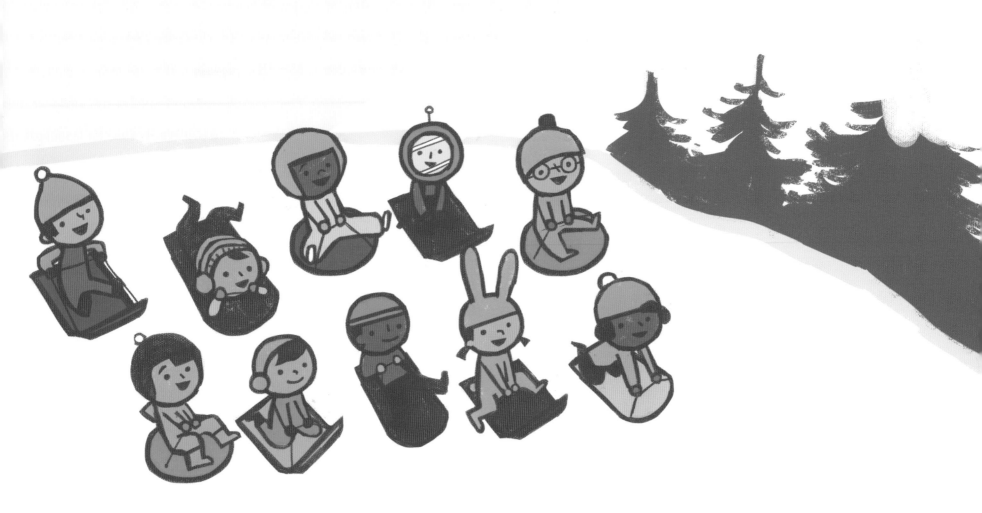

10 shiny sleds, all brand new.

8 slide down.

Now there are 2.

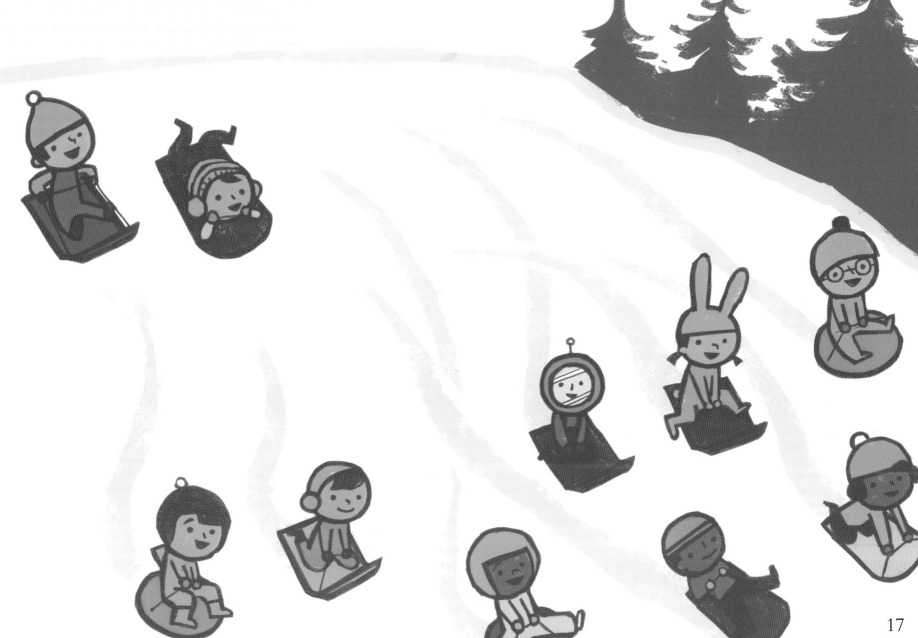

10 laughing friends are having some fun.

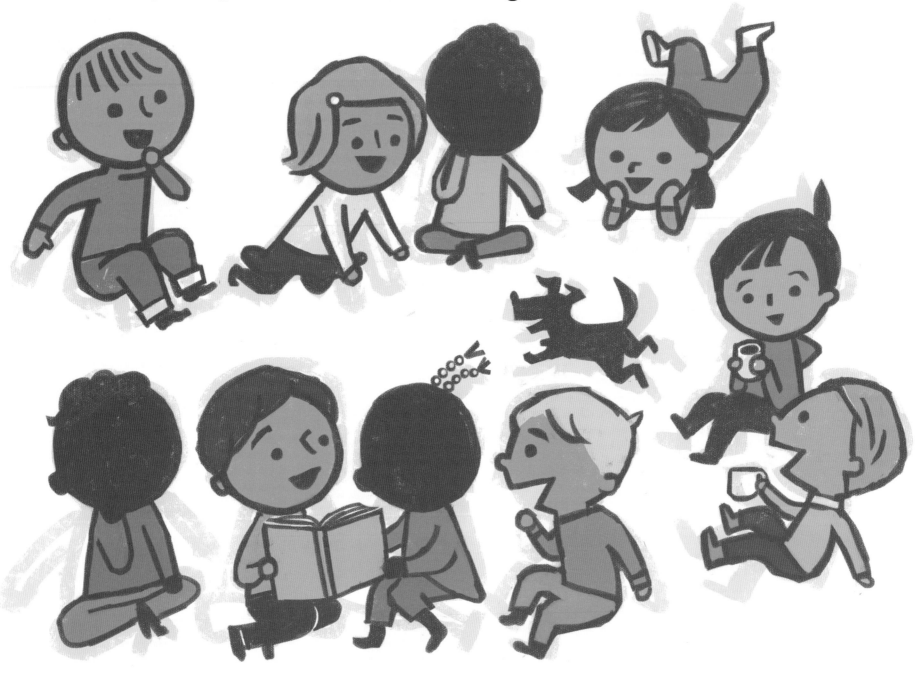

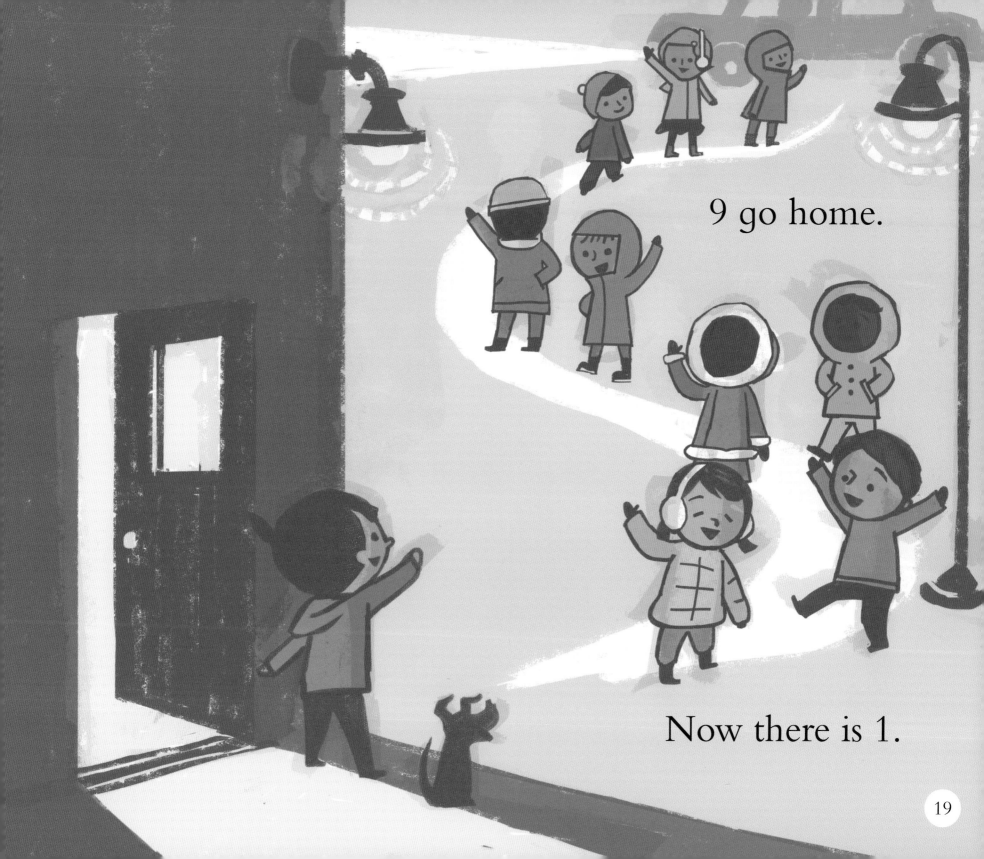

9 go home.

Now there is 1.

10 **blinking** lights are all aglow.

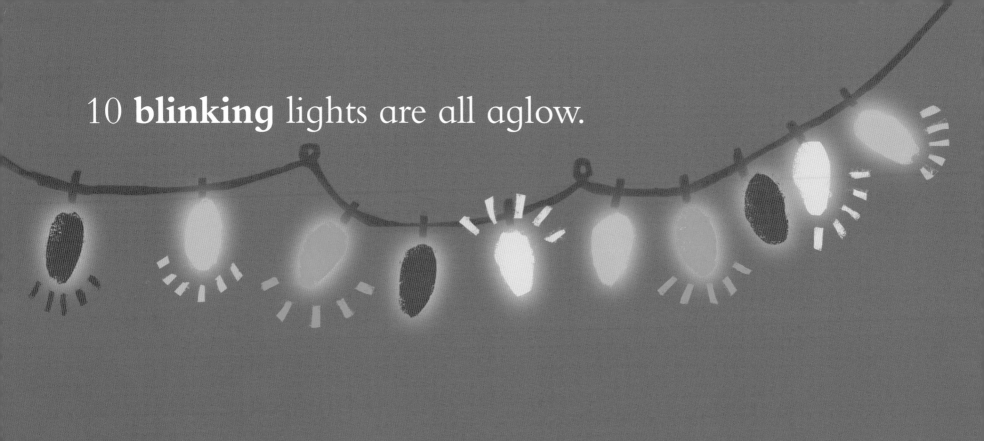

10 turn off. That makes 0.

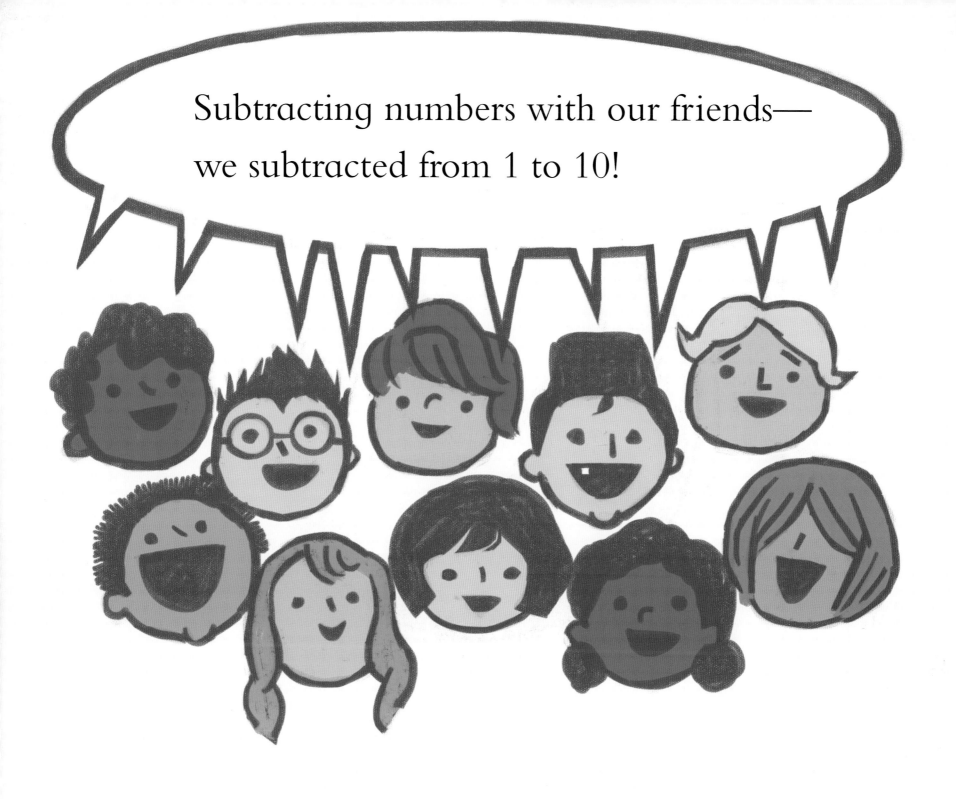

Subtracting numbers with our friends—
we subtracted from 1 to 10!

SONG LYRICS
Subtraction

Subtracting numbers with our friends—
let's subtract from 1 to 10!

10 skaters skating in a line,
1 goes home. Now there are 9.

10 snow geese soar over a lake.
2 fly away. Now there are 8.

10 cookies straight from the oven.
3 get eaten. Now there are 7.

10 candles in their candlesticks.
4 blow out. Now there are 6.

10 silly snowmen look alive.
5 melt away. Now there are 5.

10 hockey players try to score.
6 fall down. Now there are 4.

10 bright cardinals up in a tree.
7 fly off. Now there are 3.

10 shiny sleds, all brand new.
8 slide down. Now there are 2.

10 laughing friends are having some fun.
9 go home. Now there is 1.

10 blinking lights are all aglow.
10 turn off. That makes 0.

Subtracting numbers with our friends—
we subtracted from 1 to 10!

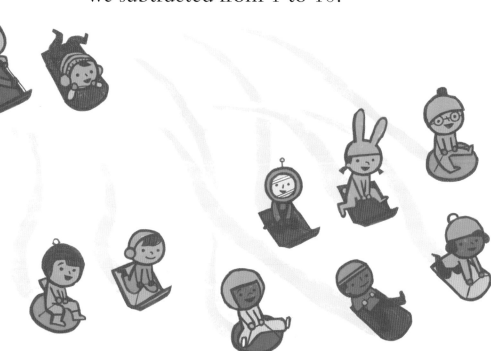

Subtraction

Americana
Erik Koskinen

Intro/Outro

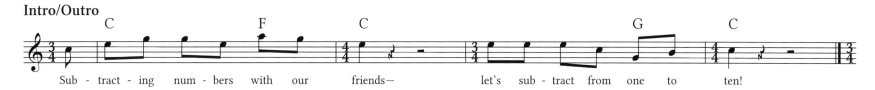

Sub - tract - ing num - bers with our friends— let's sub - tract from one to ten!

Verse

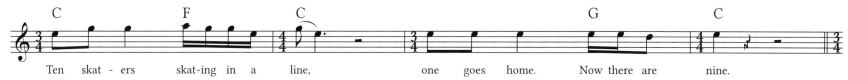

Ten skat - ers skat-ing in a line, one goes home. Now there are nine.

Verse
10 snow geese soar over a lake.
2 fly away. Now there are 8.

Verse
10 cookies straight from the oven.
3 get eaten. Now there are 7.

Chorus

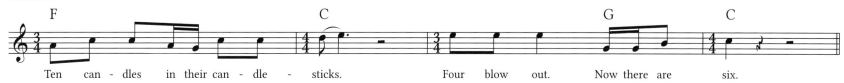

Ten can - dles in their can - dle - sticks. Four blow out. Now there are six.

Verse
10 silly snowmen look alive.
5 melt away. Now there are 5.

Verse
10 hockey players try to score.
6 fall down. Now there are 4.

Chorus
10 bright cardinals up in a tree.
7 fly off. Now there are 3.

Verse
10 shiny sleds, all brand new.
8 slide down. Now there are 2.

Chorus
10 laughing friends are having some fun.
9 go home. Now there is 1.

Chorus
10 blinking lights are all aglow.
10 turn off. That makes 0.

Outro
Subtracting numbers with our friends—
we subtracted from 1 to 10!

GLOSSARY

blinking—lights that go off and on rapidly

hockey—a game played on an ice rink between two teams; the teams use sticks to try to shoot a puck into a goal

soar—to fly up high in the air

GUIDED READING ACTIVITIES

1. Practice what you learned in this song. Find ten pennies. Take one penny away. How many do you have left? Then from the ten pennies, subtract two pennies. How many are left? Do this again for three, four, and five pennies.

2. What is your favorite winter activity? Draw a picture of yourself having fun doing this activity.

3. During the winter, what animals do you see where you live? Do you see different animal during other seasons?

TO LEARN MORE

Corcorane, Ann. *Subtracting*. North Mankato: Capstone, 2012.

Moon, Walt K. *Winter Is Fun!* Minneapolis: Lerner Publications, 2017.

Penn, M. W. *It's Subtraction!* North Mankato: Capstone, 2012.

Steffora. Tracey. *Taking away with Tigers*. Chicago: Heinemann Library, 2014.